IMAGES
of America

WOODSTOCK

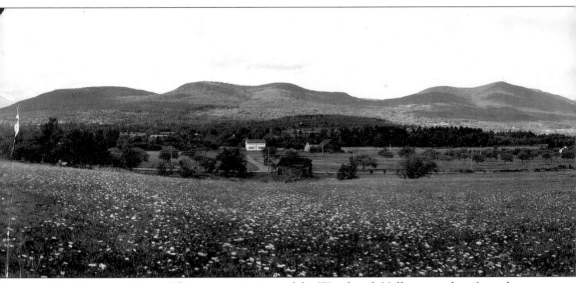

THE JOHNSON FARM. This panoramic view of the Woodstock Valley was taken from the upper portion of the sledding field. The Johnson farm was later known as the McEvoy Estate. The grounds sported a pool and a tennis court. (Courtesy Woodstock Library Collection.)

IMAGES
of America

WOODSTOCK

Janine Fallon-Mower

ARCADIA

First published 2002
Reprinted 2003

Published by Arcadia Publishing,
an imprint of Tempus Publishing Inc.
Portsmouth NH, Charleston SC, Chicago,
San Francisco

Printed in Great Britain

Library of Congress Catalog Card Number: 2002106585

For all general information, contact Arcadia Publishing:
Telephone 843-853-2070
Fax 843-853-0044
E-mail sales@arcadiapublishing.com
For customer service and orders:
Toll-free 1-888-313-2665

Visit us on the Internet at www.arcadiapublishing.com

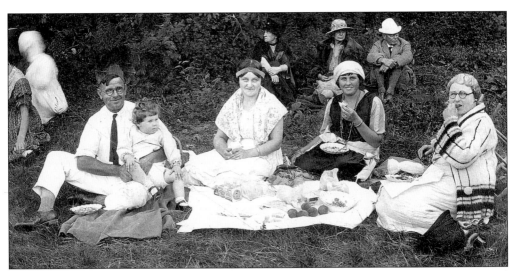

THE GRIFFIN HERRICK FAMILY AT THE MAVERICK FESTIVAL, AUGUST 15, 1924. Family and friends enjoy a picnic of fruit, bread, crackers, and cheese on their blanket at the Maverick Festival. From left to right are local builder Griffin Herrick, Barbara Herrick, Ada Wilber Herrick, and two unidentified persons. For the festival, the locals and the artists dressed in either their Sunday best or exotic costumes and spent the day in an atmosphere of fun and frolic. (Courtesy the Ada Wilber Herrick collection, Historical Society of Woodstock.)

CONTENTS

ACKNOWLEDGMENTS

I would like to thank all the wonderful people who so generously shared their time and their photographs with me. I was truly moved by each person's enthusiasm when asked to share family photographs and anecdotal information about life in Woodstock. As we reviewed old family albums, diaries, scrapbooks, and newspaper clippings, the common feeling was a sense of pride in community and desire to share the local historical details that are held within the images. Many thanks to Barbara Mower Lowenthal, Anne Mower, Shelli and Dave Mellert, Sue Mellert, Linda Tiano, Jo Spinelli, Helen and Chuck Howland, Bruce Smith, Dj Stern, Ole and Marianne Sjursen, Harry Park, Gail Brownlee, Alice Lewis, Lorraine Elliott, Dot Wright, Doris and Stewart DeWitt, Lena Woodard, Dot Haeussler, Maynard Keefe, Marlene Letus, Sondra Shultis, Roy Van Wagner, Jay and Donna Peterson, Sue Goffreddi, Roger and Elsie Shultis, Denise Clark, Gail Carl, Gail and Archie Bonestell, Bruce Reynolds, Donna and Eric Stoutenberg, Elaine VanDeBogart, Howard Shultis, Velma Grazier, Ken Peterson, Doris Smith, Randy Smith, Kathy Foster, Victor and Jane Allen, Harry Kennedy, Andre Neher, Jon D. Elwyn, Kathy and Bob Gordon, Mary Elwyn, Bob and Pat Hastie, Dotty Sonnenberg, Lew and Val Berryan, Harley Avery, Shelby and Ned Houst, Edna Hoyt, Frank Turmo, Marie Raymond, Rowanna Koester, and Jim Kinns. Without their assistance, this book would not have been possible.

I would also like to thank the Historical Society of Woodstock Board of Directors for providing me with access to the society's photograph collection and historical records. Thanks also go to the Woodstock town board for the use of photographs from the Town of Woodstock Historic Structure Photograph Collection.

I would especially like to thank my husband, John Mower, for reviewing the text and guiding me though the difficult process of eliminating photographs; Allan Mower for encouraging me to explore life to its fullest extent when hiking the Cliffs of Mohr; Colleen Mower for her unwavering support and words of encouragement; and Jason Young for his assistance with photograph setup and layout. Finally, an expression of gratitude goes to the Great Spirit of Life, which guides me and drives me into such wonderful projects.

BIBLIOGRAPHY

Evers, Alf. *Woodstock, History of an American Town*, Overlook Press, Woodstock New York, 1987.

Rogers, Frances. *The Story of a Small Town Library*, Overlook Press, Woodstock, New York, 1974.

Rose, Will. *The Vanishing Village*, Twine's Catskill Mountain Bookshop, Woodstock, New York, 1963.

INTRODUCTION

When you speak with anyone who has resided in Woodstock since the 1940s, almost invariably Deanies will come up in the conversation. Deanies, one of Woodstock's most popular restaurants during the time period from the 1940s to the 1970s, had as its motto, "Known from Coast to Coast." Later, as the 1980s got a foothold in Woodstock, many people in the business community began to refer to the town as the "Most Famous Small Town in the World." These mottos reflect the influences that people from the far corners of the world have had on this small upstate community and that Woodstockers, in turn, have had on the global community. Woodstock gained new significance with the founding of the Byrdcliffe Arts and Crafts Colony in 1902. The 1969 Woodstock Music Festival, held in Bethel, propelled Woodstock into the world of music and multimedia arts. It is easy to overlook the generation of people who shaped the quiet little community that previously existed. The images and stories in this book have been selected to represent the life and times of those earlier people, the descendants of Woodstock's original settlers.

Woodstock was first settled in the 1760s. At that time, many of the families were tenants living on the Livingston and Hardenberg Patents. Hardy settlers carved out small communities in what are known today as the hamlets of Woodstock. Slowly, each area was settled, work was begun on the land, and industry was developed according to the natural resources available. According to Alf Evers, author of *Woodstock, History of an American Town,* as early as 1762, Robert Livingston ordered that a sawmill be constructed at the site of the present-day Woodstock Country Club. While Colonial citizens of the area were preparing to declare their independence from the King of England, a Mr. Newkirk was establishing a residence at the crest of the hill, leading up from Livingston's sawmill, right in the middle of today's village green. Once the Revolutionary War ended, people began to move west from the settlements along the Hudson River and north away from the Colonial capital city of Kingston in search of fortune and land upon which to raise families and prosper. Thus began the migration of the Dutch, German, Palatine, Irish, and English settlers into the 72-square-mile area of present-day Woodstock.

Lumber from sawmills, flour from gristmills, window glass from the glass factories, rock slabs from bluestone quarries, shingles, barrel staves, table legs, oats, corn, and hay are just a few of the products that Woodstockers worked to harvest from the land. Many of these products were sold in local markets as the primary means of support for the families who settled in the beautiful hills and valleys of Woodstock. The population of Woodstock expanded during the early 1800s with the brief appearance of the glass factories in Bristol, now known as Shady. Strategically located along the powerful waters of the Sawkill, near present-day Reynolds Lane and MacDaniel Road, the glass factories also had accessibility to firewood for fuel, and they continued to operate until less expensive methods of production came into being. At the beginning of the 19th century, the tanning industry developed in the area. The main tannery was set up near the commercial center of Woodstock. Bark from local oak, hemlocks, and other native hardwoods fueled the fires for the hide tannery along Tannery Brook.

Apparently as early as 1790, a tavern existed on the outskirts of Woodstock. It was run by a man named Philip Bonesteel. Then, in the early 1800s, one of Woodstock's earliest hotels was built on Tinker Street, near Orchard Lane. It was operated by the Elwyn family. Even before the Civil War, visitors came to stay in Woodstock to hike the Overlook and enjoy the breathtaking view of the surrounding countryside. In 1863, the MacDaniels began hosting summer visitors at their Cold Spring House. With the increase in the number of travelers seeking refuge from an industrial environment, rumors spread about investors who were interested in building a huge hotel on top of the Overlook.

At one point, a way station was set up in the Wide Clove area. It served as a rest stop for weary hikers and their horses, a welcome respite before the last leg of their journey up Overlook Trail. In 1865, George Mead built a two-story boardinghouse at the Wide Clove site to

accommodate the many seekers of the beautiful vistas and clean mountain air that the 3,000-foot elevation provided. Thus, Woodstockers began to serve summer boarders with overnight accommodations—the start of a growing relationship that continues today.

The book's six chapters are organized geographically to unfold in a manner that will allow you to tour the old hamlets of Woodstock. The hamlets generally included a store, a church, a post office, and a school. The people who lived in the hamlets usually had a mill, a quarry, or a farm that served as the means of employment. As you drive or walk around Woodstock, allow your eyes to look beyond the colorful shops and the long, secluded driveways. A crumbling stone wall, a cluster of apple trees, a forsythia hedge, or a sunken foundation may reveal to you evidence of life in Woodstock in the 18th or 19th century.

On Our Village Green

There is a pole, all painted white
Where our flag flies, from morn to night
And at the end of each day it's
Carefully folded and put away.
There was an Honor Roll made with
A list of our soldiers, whose lives they gave.
On it was placed for all to see
What price is paid for liberty.
And nearby an urn was made with
Our bluestone so carefully laid.
It was filled with flowers of every kind
With here and there an ivy vine.
Now of all this, we were very proud
Because it is our community.
Once a year we have a fair
With tables placed here and there
Soon they're laden with jelly, pies and cake
And quilts and things that ladies make.
A stand was built where the band would play
With balloons and flags fluttering away.
There were toys and games—a fish pond too
With little prizes, wrapped in blue.
Peanuts popcorn and lemonade.
Oh look! Now here comes the parade.
I see the flag on the big base drum
Around the corner, here they come
The police and firemen are marching too.
How proud they look in their suits of blue.
Now come the legion wearing their soldier caps.
Ladies auxiliary with their capes all wrapped.
Last we see Girl and Boy Scout troops
With their leaders they all salute
Now the band begins to play . . .
And everything is in full sway.
Soon it is nearly dark
And boys with their firecrackers begin to pop.
With sparklers flying here and there
The smell of cigar smoke in the air.
Now the rockets begin to fly—

With a burst of color in the sky
and now you know the reason why,
For this used to be our Fourth of July.

At Christmas time, it's a different scene
With fresh snow covering our village green.
A Nativity is put in place
With shepherds and sheep
And quietly their watch they keep.
And in the back, not very far
The three wisemen and evening star.
Soon the choir begins to sing
Glory to our newborn king

Now our tree is all aglow—
Its reflection can be seen in the fresh
 fallen snow.
Then we hear a great applause
Here comes dear old Santa Claus
With jingling bells and a bag on his back,
He was quickly seated and given a snack
Next all the children gather around
With their arms outstretched and hands
 open wide
To see what Santa has inside . . .
After the last little hands goes out,
You can hear Santa shout: "Merry Christmas!"
Then the sound of jingle bells
And Santa bids us all a good farewell.
Now all of this you do not see
For it is in my memory
I leave you this so you too can see
Just how our green used to be.
And now that I am far away,
I've often heard travelers say
How lovely was our Woodstock scene
Because of you Village Green.

—Ethel Cashdollar White

One

THE CROSSROADS
TO THE OLD FIREHOUSE

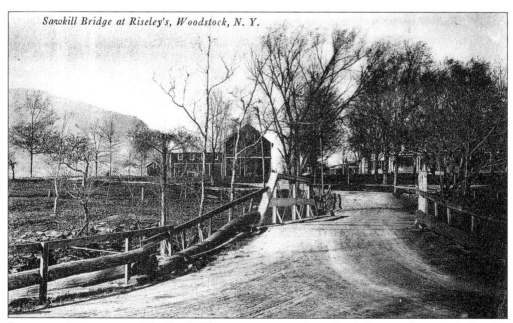

ENTERING WOODSTOCK. The Sawkill begins its journey from Catskills, runs through the hamlet of Shady, and joins with the Tannery Brook near the Pine Grove. The creek continues south and east though Zena to join with the Esopus creek. The Riseley boardinghouse and barn, built in the 1800s, provides a daily reminder of Woodstock's rural farm heritage. This view is looking toward the boardinghouse from the Woodstock–West Hurley Road. (Courtesy Lena Woodard.)

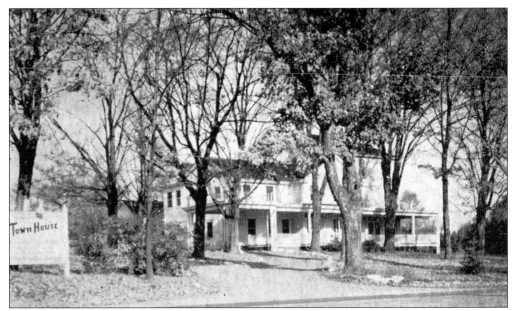

AARON RISELEY'S BOARDINGHOUSE. Built after the Civil War, this was the home of the Aaron Riseley family. Aaron Riseley was one of a few Woodstock men who served in the Union army. He was captured and held at the Andersonville Prison. At one time, the property included two large barns. The Riseley farm covered the present-day sites of the elementary school, country club, and playhouse. (Author's collection.)

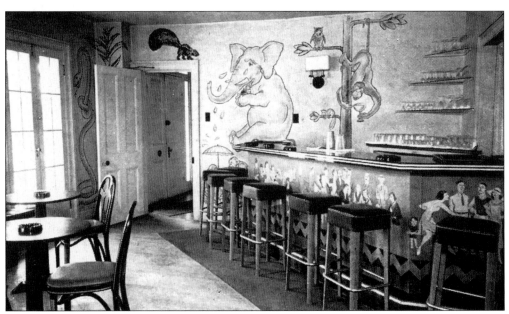

AN INTERIOR VIEW OF THE TOWNHOUSE. The Riseley House has changed hands many times in the 20th century. It has been Deanies's, Margaret's, June Holbrook's, and the Townhouse. Depending on their age, Woodstockers use the name they remember it as. During the Townhouse era, the bar and restaurant establishment catered exclusively to Woodstock's gay community. (Author's collection.)

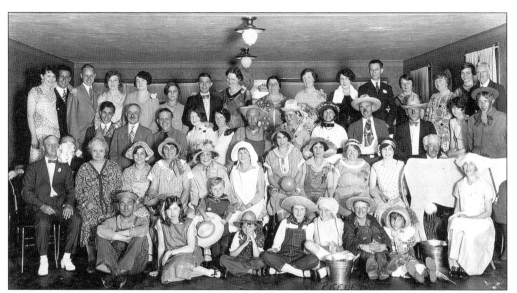

INSIDE THE RISELEY HOUSE, SEPTEMBER 2, 1927. Visitors to Woodstock in the 1920s began the last leg of their travel to the area from the West Hurley train station. Often, the owner of the boardinghouse would send a wagon, driven by a family member, to collect the boarders and their luggage. Summer boarders and locals, many dressed as country bumpkins, pose in the main room of the Riseley House. (Courtesy Lena Woodard.)

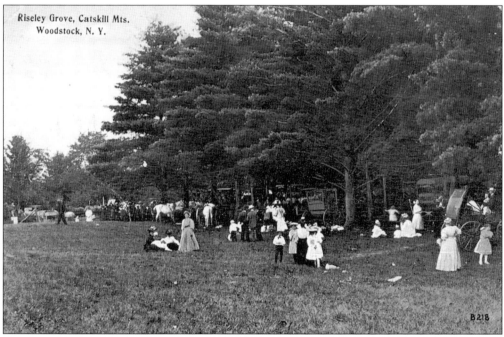

AT THE EDGE OF RISELEY'S PINE GROVE. As early as 1897, the Riseley family sponsored dances in the Pine Grove for residents and summer boarders. The popular picnic area stretched from an open field above the Sawkill bridge to the area where the Tannery Brook meets the Sawkill Creek. Enterprising locals sold lemonade, ginger ale, and watermelons to the attendees. The tall pine trees provided cool shadows in which to escape the summer heat. (Author's collection.)

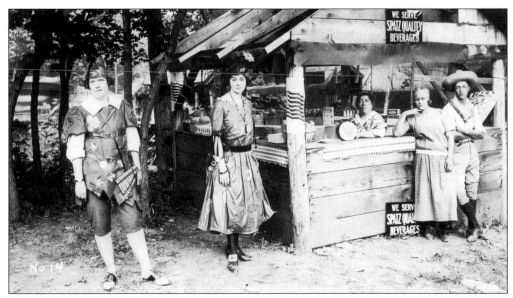

THE REFRESHMENT STAND. It is August 31, 1923, and customers have gathered around Aunt Nellie Jane Mower's refreshment stand at Riseley's Pine Grove. From left to right are two unidentified persons, Nellie Jane Mower, her niece Catherine Mower, and one unidentified person. (Courtesy Lorraine Elliott.)

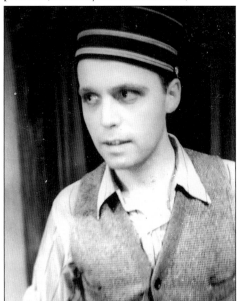 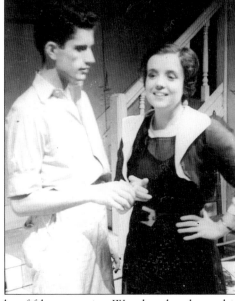

LEFT: ROBERT ELWYN, IN NIGHT MUST FALL. Bob, a fifth-generation Woodstocker, began his theater career as an actor in summer stock at the Maverick. He advanced to manager and, over time, became frustrated with the inadequate conditions that the Maverick Theatre provided. Thus, he decided to open and operate his own theater, and he tapped his scenic designer Ned Milliken to be the architect. (Author's collection.) RIGHT: ROBERT ELWYN'S PRODUCTION OF PENNYWISE. Jimmy Roberts and Francis Bavier perform at the Maverick Theatre in 1937. The actors and students stayed for the season at Byrdcliffe or in the boardinghouse known as Brooklands, on Allen's Hill. (Author's collection.)

THE CONSTRUCTION OF ROBERT ELWYN'S WOODSTOCK PLAYHOUSE, 1938. Robert Elwyn commissioned his uncle and local builder Arthur Wolven to build a theater on property located just west of the boardinghouse and formerly owned by Woodstock Properties Inc. Elwyn closed the land deal with George Neher in May, and amazingly the theater opened by the end of June. It served the summer stock theater group and freed Elwyn from his lease arrangement with Hervy White at the Maverick Theatre. (Courtesy Historical Society of Woodstock.)

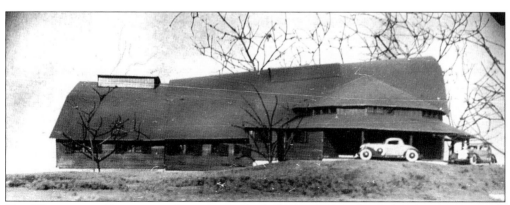

THE WOODSTOCK PLAYHOUSE, JUNE 1938. A whole generation of Woodstockers grew up with summer stock. Each summer season brought out theatergoers dressed in their white elegance, pearls, fur stoles, and summer suits. Every Thursday through Sunday night, the parking lot would fill and a sense of excitement would shiver up the main street into Woodstock. "Meet me for dinner at Deanies after the show." (Courtesy Historical Society of Woodstock.)

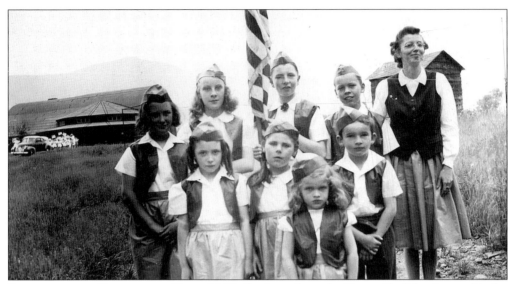

PREPARING FOR DECORATION DAY, 1942. Students from the Bearsville School assemble for the town's Decoration Day parade. Their teacher, Evelyn Stone, is on the far right. The Woodstock Playhouse is in the background. (Courtesy Roger Shultis.)

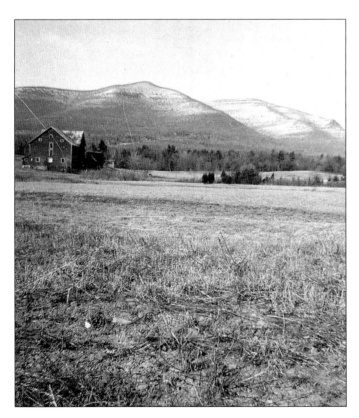

THE VIEW. Overlook Mountain commands the center of attention in the background. The Elwyn-Hasbrouck barn is in the foreground. Today, the view includes Bradley Meadows shopping plaza and the BobWhite housing development. (Courtesy Barbara Mower Lowenthal.)

THE HOMESTEAD. The Cashdollar family took in summer boarders at the homestead on the corner of Elwyn Lane. Today, the site is occupied by Cumberland Farms. (Author's collection.)

A Summer Ditty

There is a boarding house, not far away,
Where they serve ham and eggs, three times a day
Oh! how the boarders yell, when they hear the dinner bell
Oh! How the boarders yell, three times a day.

—Mescal Hornbeck

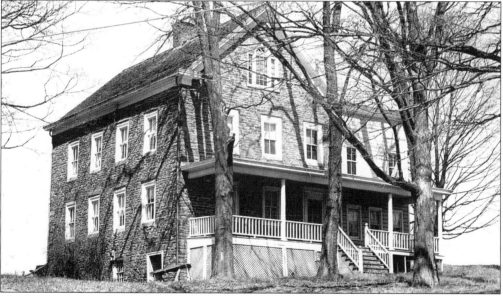

THE SHERMAN ELWYN-JONATHAN HASBROUCK HOUSE. This grand stone house was originally owned by Jonathan Hasbrouck, judge for the Livingstons. Built in 1790, the Federal-style bluestone house and its property were part of the Livingston Grant. In 1924, local supporters of the Ku Klux Klan movement held a cross burning in the cornfields that lay to the east of the barns. (Courtesy Alice Lewis.)

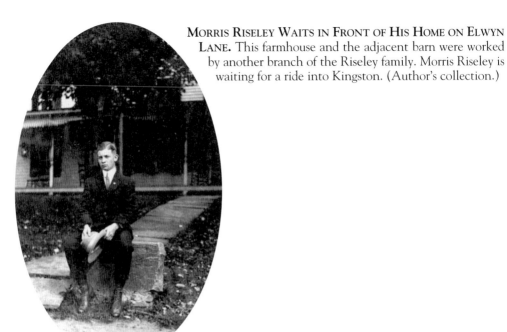

MORRIS RISELEY WAITS IN FRONT OF HIS HOME ON ELWYN LANE. This farmhouse and the adjacent barn were worked by another branch of the Riseley family. Morris Riseley is waiting for a ride into Kingston. (Author's collection.)

WALTER MOWER'S QUARRY, 1921. Walter Mower's quarry was located at the very end of Elwyn Lane. Many men in the Woodstock hamlets worked bluestone quarries. Before the discovery of cement, bluestone served as walkways, stone road paths, well covers, and material for cellar floors. Skilled stonecutters transformed the huge blocks into functional pieces for use around the home or artistic creations for outside decorations. (Author's collection.)

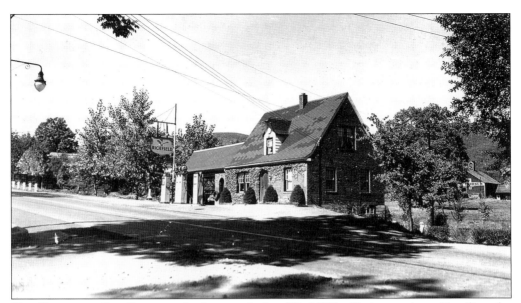

THE RICHFIELD GAS STATION. In the years before World War II, the number of families who could afford a car increased, as did the number of full-service filling stations in Woodstock. This station, on the north side of Mill Hill Road, was once operated by Vasco Pini. Charlie Kuhlman ran it from 1950 to 1968 and added the service bays in 1956. The last proprietors, Ken and Dotie Maclary Reynolds, saw the state department of transportation move the gas pumps back against the building. (Courtesy Historical Society of Woodstock.)

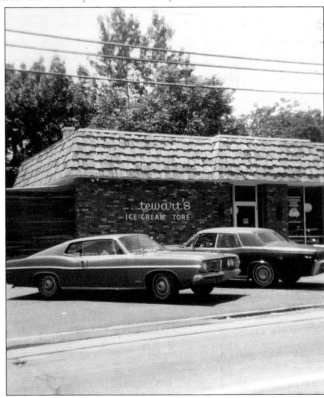

A CONVENIENCE STORE. During the 1960s, Stewart's had an ice-cream store on the south side of Mill Hill Road. The building was once a Mobil station operated by Ted Rose and, later, by Philip Spinelli. (Author's collection.)

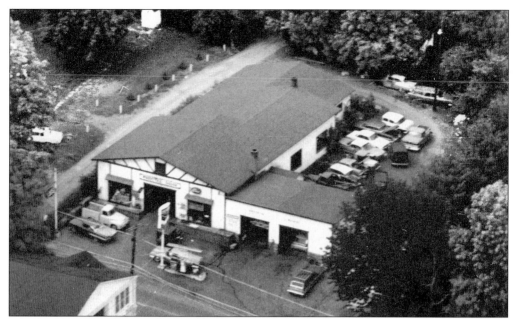

THE WOODSTOCK GARAGE. Built by Griffin Herrick, this place was first sold to Albert Cashdollar. Later, the business was operated by the Wilson-Longyear family as Woodstock's only car dealership, with Ford as the car of choice. Each service station employed local young men to pump the gas, check the oil, and wash the windows. The garage also served as a social and political center of activity for many years. (Courtesy Lew Berryan.)

SITTING ON THE BENCH IN THE SCHOOLYARD. Willard Wilber (left), Willis Wilber, and Lorraine Wilber pose outside the little red school building on the south side of Mill Hill Road. Many families had their homes in the buildings along Mill Hill Road. Willard and Lorraine Wilber lived next door to the school. In the background is the Woodstock Garage, and to the right is the Trolley Diner. The Becker family ran the Trolley Diner in the 1930s. (Courtesy Lorraine Elliot.)

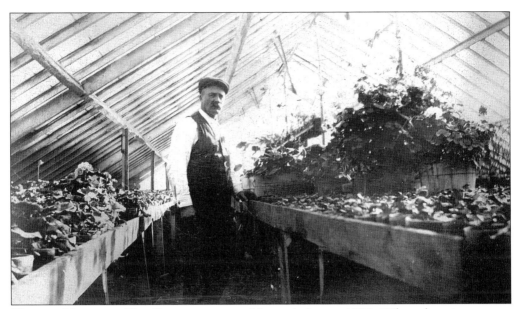

WALTER MOWER IN HIS GREENHOUSE ON MOWER'S LANE, 1922. When the winter snows prevented Walter Mower from working in his quarry, he tended hothouse plants, which were sold at Mower's Market in the spring. The greenhouse was located along the west side of Mower's Lane, in the area that is now the site of the Catskill Art Supply addition. (Courtesy Lorraine Elliot.)

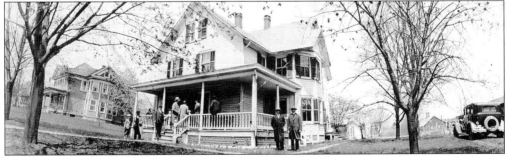

CHRIST'S LUTHERAN CHURCH PARSONAGE. This building, located on the corner of Mower's Lane and Mill Hill Road, was built in 1904 and served the Christ's Lutheran congregation as a parsonage until *c.* 1952. The Riseley barn, located at the end of Elwyn Lane, can be seen in the distance. (Courtesy Christ's Lutheran Church.)

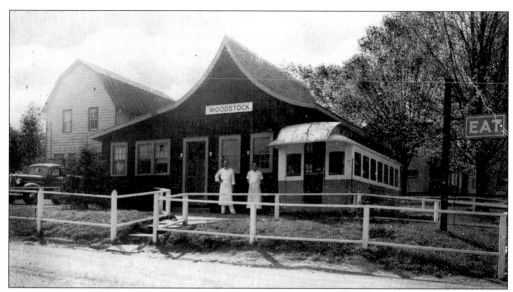

DEANIE ELWYN'S TROLLEY DINER. The main entrance to the 24-hour diner was located on Deming Street. Allen Dean Elwyn was the great-great-grandson of early Woodstock settler John M. Elwyn and Marie Bonesteel Elwyn. This view, taken from Deming Street, includes the red schoolhouse building to the left in the background. (Author's collection.)

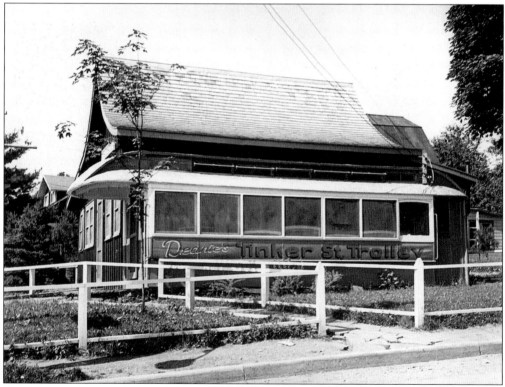

THE TINKER STREET TROLLEY. Deanie Elwyn was the premier host in Woodstock, and with the assistance of a crew of fine waitresses and bartenders, his dining establishment was a required stop on a visit to Woodstock. (Courtesy Jon D. Elwyn.)

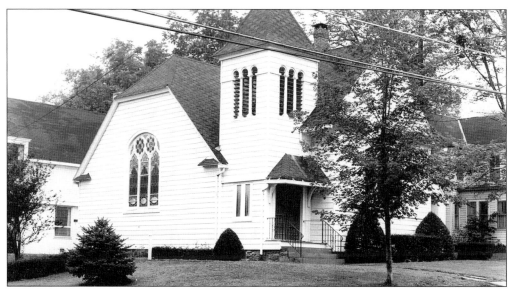

CHRIST'S LUTHERAN CHURCH. The Lutheran community of Woodstock was founded in 1806 by descendants of the German Palatine Lutherans who had fled 17th-century Germany to escape religious persecution. The original settlements were on the east and west banks of the Hudson River near Kaatsbaan. This church was erected with the assistance of builder Griffin Herrick. (Courtesy Christ's Lutheran Church.)

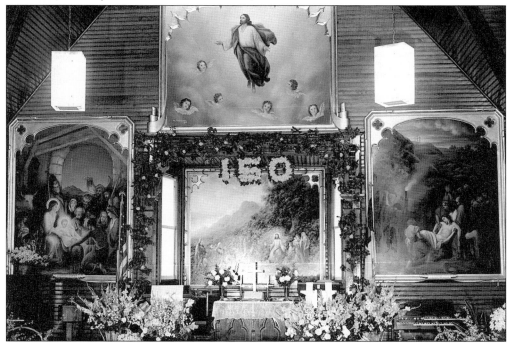

THE INTERIOR OF CHRIST'S LUTHERAN CHURCH. The original church building was erected in 1812 on land donated by Henry Bonesteel. The site was on the rock ledge three quarters of a mile east of town, just across the Woodstock Saugerties Road from Chestnut Hill Road. The congregation continued to worship there until 1895. The artwork by Paul Wesley Arndt was added to the interior of the present church in 1945. (Courtesy Doris DeWitt.)

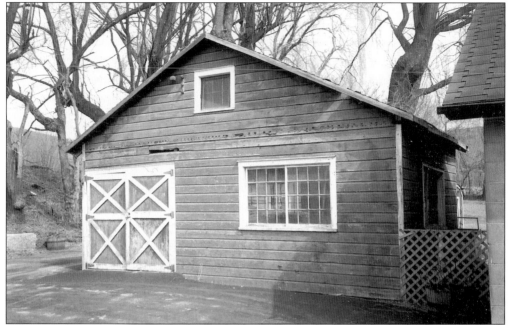

HENRY PEPER'S BLACKSMITH SHOP. One of many Woodstock blacksmiths, Henry Peper had a shop next to Stanley Brinkerhoff Longyear's livery barn. Peper also repaired wagons and forged hinges, latches, and other items local people used in their homes. (Courtesy Town of Woodstock Historic Structure Photograph Collection.)

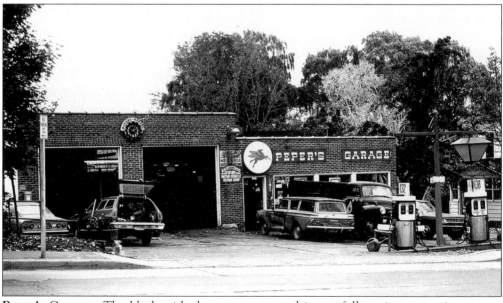

PEPER'S GARAGE. The blacksmith shop was converted into a full-service gas station as cars began to outnumber horses. Henry Peper's daughter Marge, one of Woodstock's best-known town clerks, married Clayton Harder, grandson of Levi Harder. Clayton "Potch" Harder and Marge's brothers Artie and John Peper successfully ran the garage until their retirement. Peper's was also a central location for social and political activity from the 1940s to the 1980s. (Courtesy Bill Harder.)

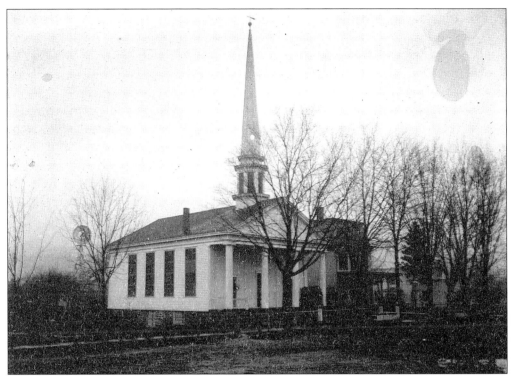

THE DUTCH REFORMED CHURCH. Next to Overlook Mountain, the Dutch Reformed Church on the green is probably the most common image people associate with Woodstock. (Courtesy Harry Park.)

LOOKING WEST ACROSS THE VILLAGE GREEN. At the beginning of the 20th century, this area was referred to as the church lawn. (Author's collection.)

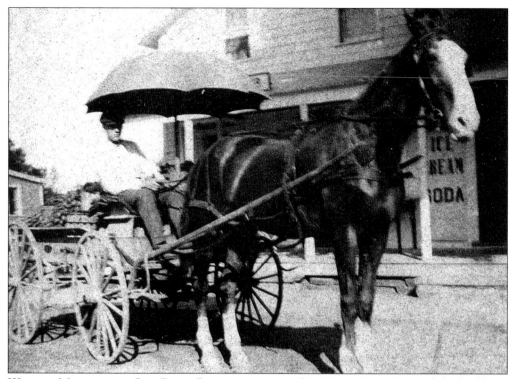

WALTER MOWER AND OLD DUKE PREPARING FOR A PEDDLING TRIP. Most of the buildings surrounding the village green area were primary residences at the beginning of the 20th century. Walter Mower and his father, Noah Lasher Mower, moved into Woodstock in the early 1880s and resided in the center of the village for the rest of their lives. Walter Mower had a weekly vegetable route, driving up through Mink Hollow to Tannersville. (Courtesy Lorraine Elliot.)

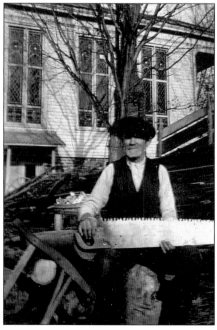

CUTTING FIREWOOD, C. 1919. Seated atop the woodpile in back of his home, Noah Lasher Mower uses a handsaw. His daughter ran an ice-cream store in the front part of the building. (Courtesy Lorraine Elliot.)

**NOAH MOWER DRIVING AWAY ON THE HAY RAKE,
1921.** During the summer months, those families
who had horses to feed worked hard to put hay up for
winter storage. The little building in the background
is the post office. The grassy church lawn has a fence
around it. (Courtesy Lorraine Elliot.)

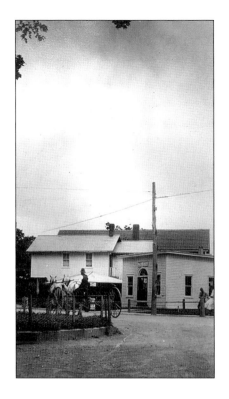

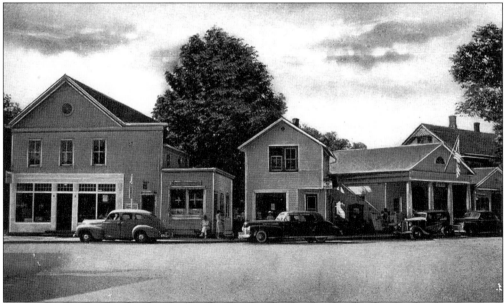

THE SOUTH SIDE OF TINKER STREET, C. 1940. If Noah Mower, shown in the previous
photograph, were to drive his hay rake forward in time, he would ride past this row of buildings
on Tinker Street. The Elwyn family ran a general store, had a deli with a catering business, and
sold real estate from most of these buildings until the late 1920s. (Courtesy Harry Park.)

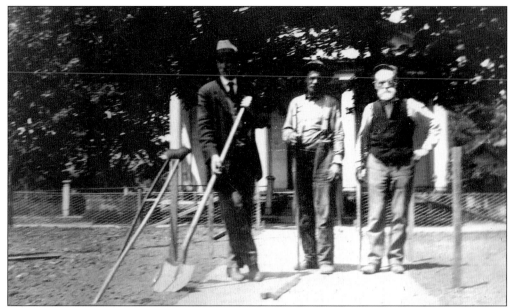

REPAIRING THE CHURCH LAWN, MAY 1921. This grassy lawn has always been part of the Dutch Reformed Church property. Making repairs to the church lawn are, from left to right, Wesley France, Walter Mower, and Asa Wolven. As the center of town became more popular, this small area of land had to endure the demands of heavy foot traffic. The public space referred to as the village green now has the appearance of an outdoor mall area. (Courtesy Lorraine Elliott.)

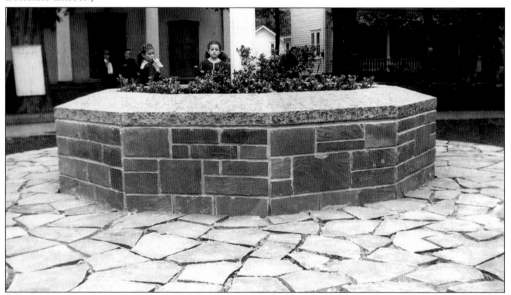

THE WAR MEMORIAL. Just prior to the end of World War II, the community decided that a memorial needed to be built in honor of the Woodstockers who died while serving their country. A fund was established, and donations flowed in. Stonemason Charlie Joy was chosen to build the circular stone monument to surround a flagpole. Once the plaque to honor the war dead was attached to the flagpole, the rule became No Sitting on the War Memorial. (Courtesy Lena Woodard.)

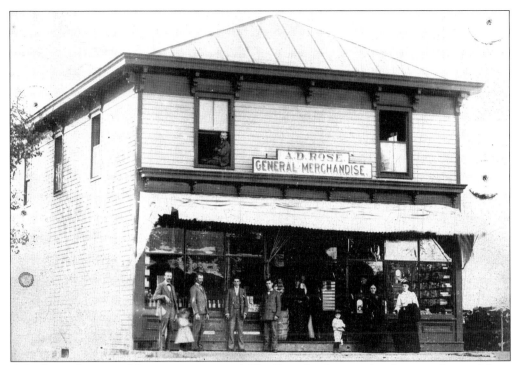

A.D. Rose General Merchandise, 1905. The Rose family owned and operated one of three general stores located in the center of town in the early 20th century. The A.D. Rose store sold all types of dried goods, stationery, newspapers, and other items required by the growing Woodstock economy. The building burned in 1911. (Courtesy Denise Clark.)

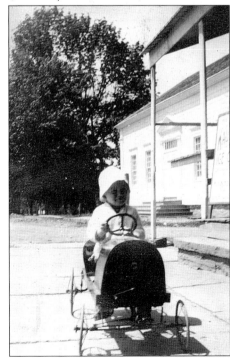

The Woodstock Artist Association. Some 19 years after the founding of the Byrdcliffe Art Colony, this gallery was built to provide space for its members to exhibit their works of art. Walter Riseley rides his toy car on the bluestone patio in front of Nellie Mower's ice-cream store. The art gallery is in the background. (Courtesy Lorraine Elliott.)

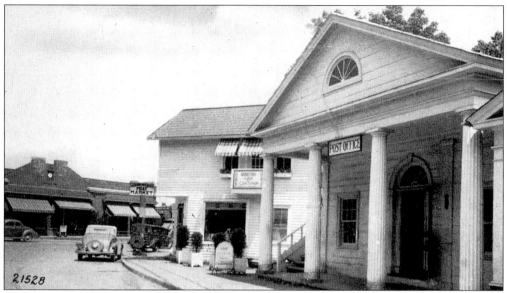

THE WOODSTOCK POST OFFICE, 1930S. This beautiful four-column building replaced the little bandbox that served as the post office in 1921. A sign on the upstairs portion of the building next to the post office reads, "Guild of Craftsman." Another sign, at street level, reads, "Meat Market." To the left is the large red-brick Longyear building, which was built to replace the Woodstock Valley Hotel. (Author's collection.)

THE GRAND EAGLE. When the post office was renovated in the 1950s, it lost its columns but gained an eagle. The eagle now watches over the display from its perch at the Town of Woodstock Historical Society Museum, on Comeau Drive. (Author's collection.)

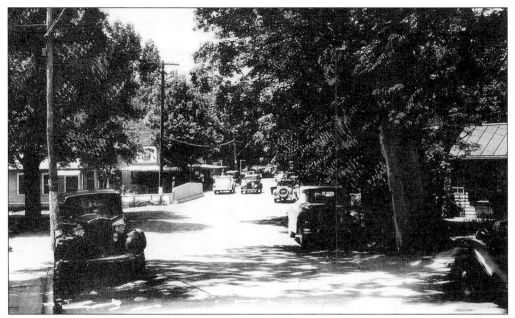

THE NOOK, FROM THE VILLAGE GREEN, LOOKING WEST. The Nook was a popular eatery of the 1940s and 1950s that was created out of an old barn. The covered porch had tables and chairs for outside dining on nice summer days. The sign on the porch advertises beer and ice cream; the upstairs has living quarters. In the 1960s, the Nook was transformed into the famous nightspot the Café Espresso. (Author's collection.)

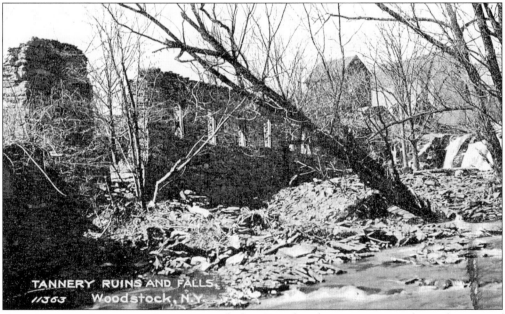

TANNERY RUINS AND FALLS,
11363 Woodstock, N.Y.

THE TANNERY FALLS AND RUINS. Long before Woodstock was an artist colony, this strip of land near the intersection of Tinker Street and Tannery Brook Road was home to a tannery. The *Beers Atlas* identifies a tannery at this site in 1875. People who grew up in town in the 1930s and 1940s recall ice-skating on the pond below the bridge and following the frozen brook back around the Old Forge House. (Courtesy Harry Park.)

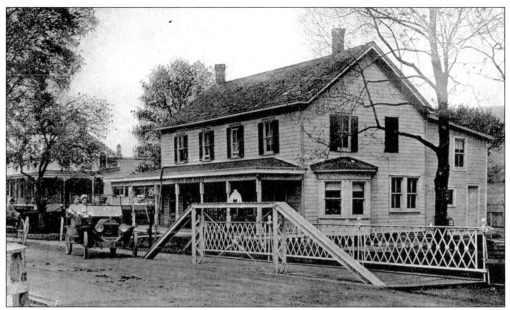

THE TANNERY BROOK HOUSE. The Tannery Brook House was also known as the Old Forge House. In the late 1780s, this area was the site of a sawmill, a gristmill, and a blacksmith shop. Note the wide wraparound porch on the building just up the street. (Author's collection.)

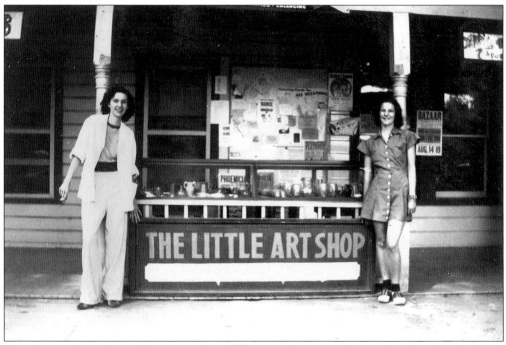

THE LITTLE ART SHOP. During the late 1930s, this shop served as a gathering place for local teens and theater people staying at Byrdcliffe. Shown are Flo Davis (left) and Beth Adams. (Author's collection.)

YOUNG BOB SMITH, APRIL 1928. Bobby Smith and his friend pose in front of the Smith homestead on Neher Street. On the left is the Jones house with chicken coops behind it—the Jones girls raised chickens. In the far distance is the outline of Overlook Mountain. (Courtesy Doris Smith.)

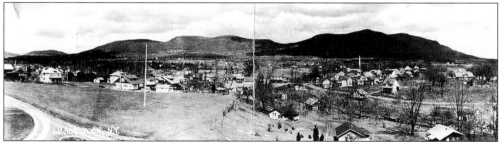

WOODSTOCK CENTER, FROM ALLEN'S HILL, C. 1920. This panoramic view of the center of Woodstock was taken looking toward Overlook Mountain from what is now the Legion Post 1026 building. The steeple of the Dutch Reformed Church helps to orient the viewer. (Author's collection.)

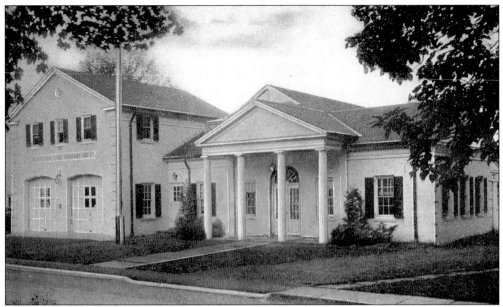

The New Town Hall and Fire Station, Tinker Street. The town hall and fire station complex was erected during 1936 and 1938. It included the town clerk's office, a meeting hall, and a theater stage. The Woodstock Fire Company continued the use of a fire siren code adopted in 1934 to summon volunteer firemen. The siren would sound, and local phone operators would relay the calls and alert the fire officials. It was not until at least 10 years later that a dispatch system was put in place. (Courtesy Harry Park.)

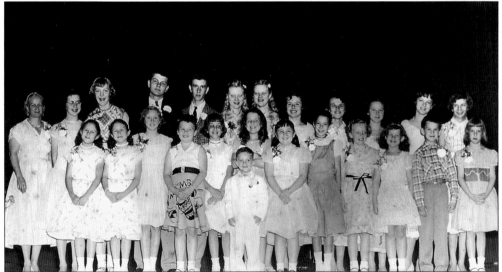

A Piano Recital by Students of Ann Cousins. Ann Cousins (back left) and her students proudly pose on the stage in the Woodstock Town Hall. The students, from left to right, are as follows: (front row) Carol Cousins, Elaine Cousins, unidentified, Michelle Gibson, Lawrence Webster, unidentified, Laura Russell, Patty Mower, Helen Avery, Julie Holumzer, and two unidentified; (back row) Dorothy Watson, Ann Ohl, Jim Cousins, unidentified, the Ross twins, Jeanne Cousins, Marilyn Wolven, unidentified, Carol Ann Hefty, and unidentified. (Courtesy Harley Avery.)

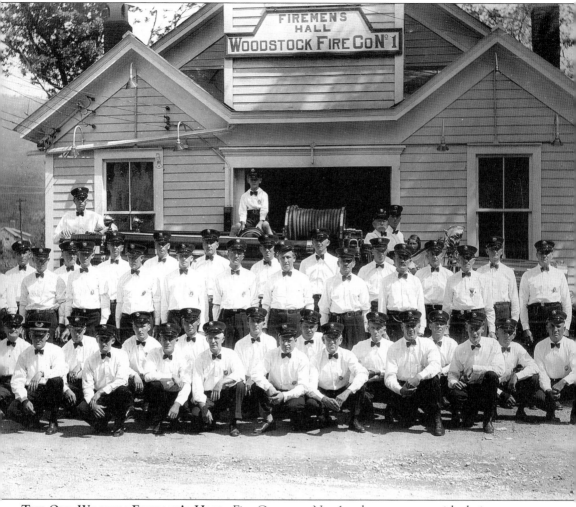

THE OLD WOODEN FIREMAN'S HALL. Fire Company No. 1 volunteers pose with their pump truck. Longtime residents will recognize most of the men, including Bob Hastie (seated on the pump truck) and, to his right, blacksmith Henry Peper (with the signature mustache). The lumber from this building was sold for $300. A group called the Citizens Union objected to the new building, but the fire company prevailed. (Courtesy Bob Hastie.)

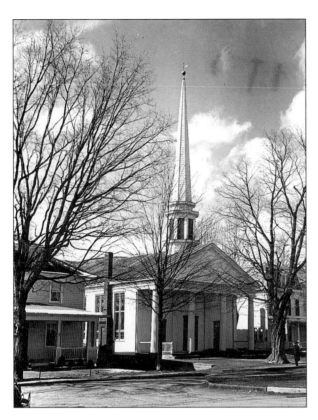

THE DUTCH REFORMED CHURCH AND SURROUNDINGS. The house to the left of the church has been used at times as a parsonage. It was built in the late 1920s by George Riseley. The house to the right of the church was known as the Edgar "Bide" Snyder house. According to author Alf Evers, Edgar Snyder was a shareholder in the corporation that was formed to build the Overlook Mountain House. Snyder contracted with the builder to have the two-story house be given the mansard roof, imitating the elegance of the first mountain house. (Author's collection.)

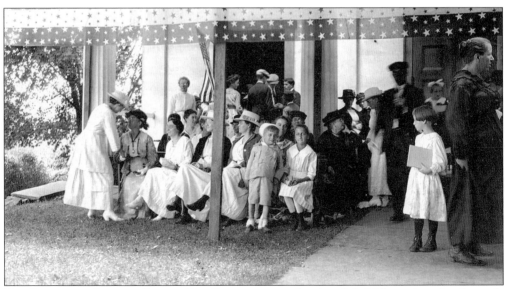

THE REFORMED CHURCH FAIR, 1920. Every summer, the church held fairs where local people sold their handcrafted items. (Courtesy the Marie Raymond collection, Historical Society of Woodstock.)

Two

THE GREEN TO OVERLOOK TRAIL

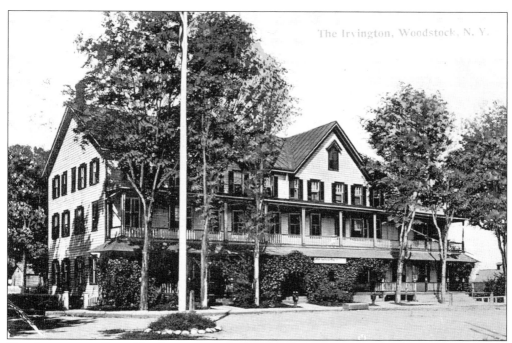

THE IRVINGTON INN. The Irvington Inn is also referred to as the Brinkerhoff Hotel or the Woodstock Valley Inn and had a succession of managers. It was built in the 1870s by William Brinkerhoff to serve as a first rest stop for travelers heading for the Overlook Mountain House. The inn was destroyed by fire in October 1929. (Author's collection.)

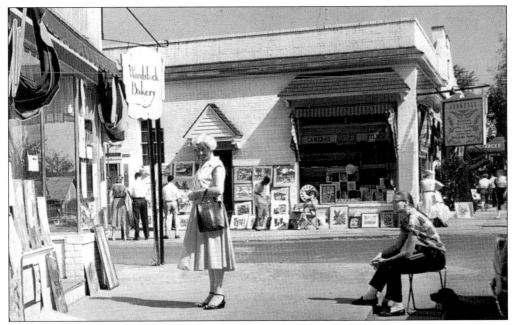

THE CORNER, C. 1960. This view shows the same corner, Rock City Road and Old Forge. At that time, Woodstock was a visual arts town, and sidewalk art sales were held occasionally. The bakery on the corner, run by Mr. and Mrs. Kirshenbaum, was a favorite Sunday morning stop for the folks who walked to St. Joan of Arc Roman Catholic Church, just up Rock City Road. The Longyear building was home to Stowell's on the Corner, a beauty parlor, and an appliance store. (Author's collection.)

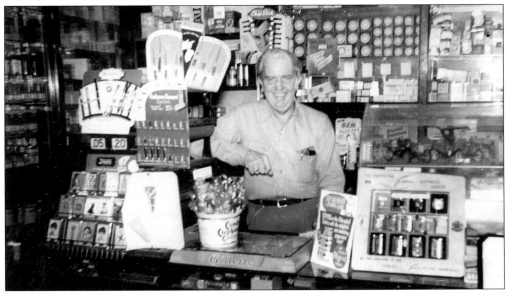

STOWEY STOWELL. In his shop, Stowey Stowell sold everything imaginable, rented bikes, and had a popular soda fountain. When he was not behind the counter, he was out selling Woodstock real estate. When all the seats at his soda fountain were taken, customers could go up the street to Forno's Pharmacy, near Joe Riela's barbershop, and have an egg cream. (Author's collection.)

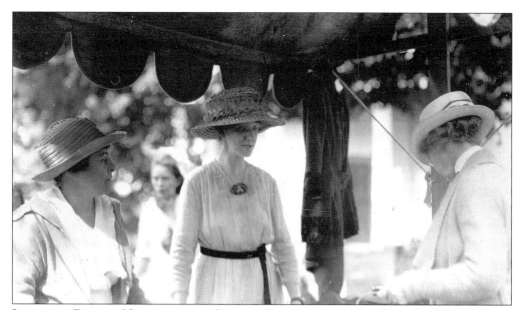

JOSEPHINE RISELEY NEHER AT THE CHURCH FAIR, C. 1920. Josephine Riseley Neher was always finely dressed and never went out without her signature hat. She enjoyed shopping for the handmade items found at the church fair. (Courtesy the Marie Raymond collection, Historical Society of Woodstock.)

THE BUS STOP. During the 1930s and 1940s, this corner served as the bus stop for high school–aged Woodstockers, such as Winnie Davis, who made their way daily to Kingston High School. Woodstock children of the 1920s who were fortunate enough to attend high school were transported by stage to the West Hurley or Cold Brook train station for the trip to Kingston. Many of these students boarded in Kingston for the week and came home on the weekends. (Author's Collection.)

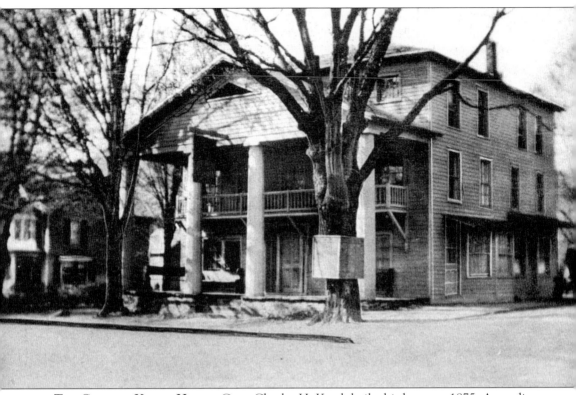

THE CHARLES KRACK HOUSE. Capt. Charles H. Krack built this house *c.* 1875. According to author Alf Evers, the captain was known as a "soldier, politician, hotel man and adventurer." Krack was serving in the state assembly when he built the two-story house in response to the momentum stirred up by the construction of the grand Mountain House on the Overlook. The building is occasionally referred to as the Longyear Hotel or Longyear apartments. Stanley Brinkerhoff Longyear was the owner of most of the land in this area in the early 1900s. (Author's collection.)

THE LONGYEAR HOUSE. Hotel owner William Brinkerhoff was one of the largest stockholders in the first Overlook Mountain House. He liked the design so much that he commissioned the builder, Lewis B. Van Wagoner, to build this house at the base of the road to Overlook in the 1870s. Brinkerhoff planned to offer additional overnight rooms for travelers seeking a dose of the healthy mountain air. (Author's collection.)

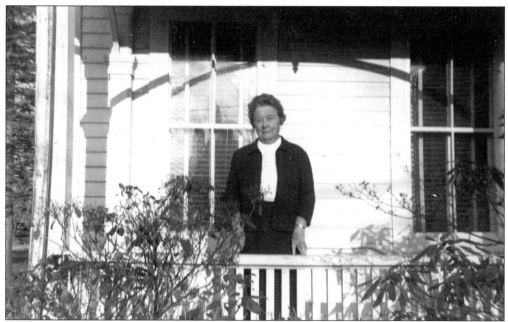

EMILY WILSON LONGYEAR ON HER PORCH. Emily Wilson Longyear, wife of Stanley Brinkerhoff Longyear, stands on her porch. The house is now the site of the Woodstock Chamber of Commerce booth. The original house was given the same mansard roof and oval-arched porch as the first Overlook Mountain House. (Courtesy Lew Berryan.)

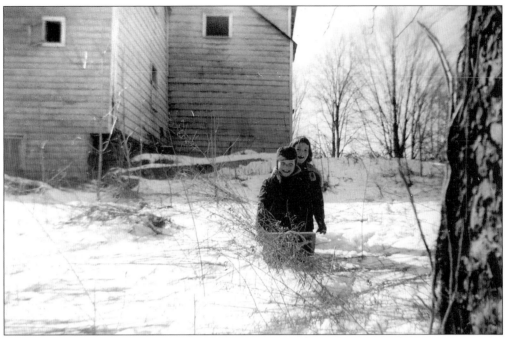

SLEDDING BEHIND THE LONGYEAR BARNS. This area right in the center of town was once the site of two large barns. The barns had horse and cow stalls, as well as lofts for hay. The chickens were kept downstairs. (Courtesy Lew Berryan.)

THE STAIRS TO THE ARTIST SLEEPING LOFTS. Jean Shultis and young Lew Berryan pose in front of the stairs leading to the barn lofts. Stanley Brinkerhoff Longyear rented out sleeping space in the lofts to the artists who came to Woostock to study at Byrdcliffe and other art schools that were established later. (Courtesy Lew Berryan.)

A LONGYEAR FAMILY GATHERING ON THE BACK PORCH. Every weekend, this very politically active family gathered on the back porch of the family homestead to discuss local, state, and national politics. The discussions were always freewheeling, and little stopped the flow of ideas. From left to right are Arne Wilson, Kenneth L. Wilson (a former assemblyman), and other family members. (Courtesy Lew Berryan.)

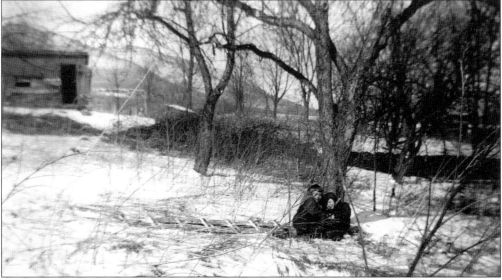

THE VIEW BEHIND THE LANDAU GRILL, C. 1956. Grandchildren of Stanley Brinkerhoff Longyear play in the apple orchard below the barns. The Longyears also had pear trees and a sandbank on their property. The outline of Overlook Mountain and Minister's Face defines the background. (Courtesy Lew Berryan.)

41

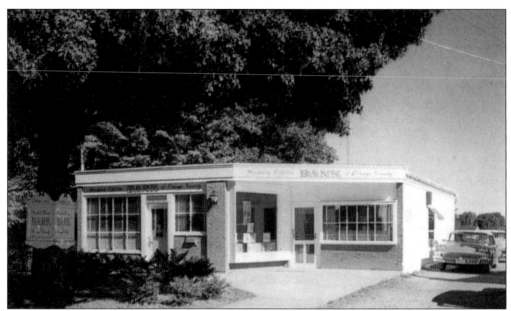

THE FIRST BANK IN WOODSTOCK. Before the Bank of Orange and Ulster arrived in Woodstock, people had to travel to Saugerties or Kingston to open a bank account. Due in part to Assemblyman Ken Wilson's association with the bank, the board of directors purchased a little triangular plot of land next to Stanley Brinkerhoff Longyear's home and built a branch office. (Author's collection.)

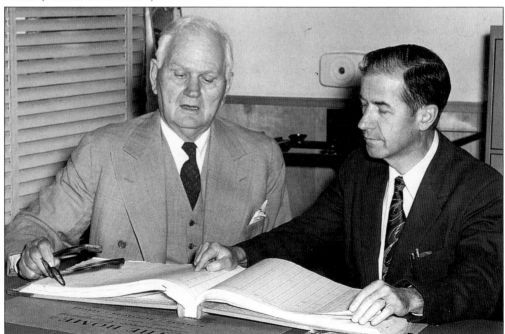

THE HOMETOWN BANK. Woodstockers were treated like family by their new hometown bank. They were given credit based on their reputation in the community. Pictured are bank officials Frank Benson (left) and Albert Varney. The tellers were all local women who knew everyone by name. (Courtesy the Kiki Randolf collection, Historical Society of Woodstock.)

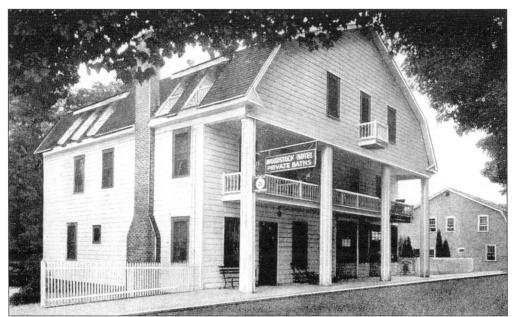

THE WOODSTOCK HOTEL. Stanley Brinkerhoff Longyear erected this building in the early 1930s. It was home to a small IGA food store for a brief period of time. (Courtesy Harry Park.)

THE SS SEA HORSE. In the years following World War II, the Sea Horse was a favorite gathering spot for locals and artists. Once a barn, the building was used as a recreation center for young people before it became the Sea Horse. (Courtesy the John Brown collection, Historical Society of Woodstock.)

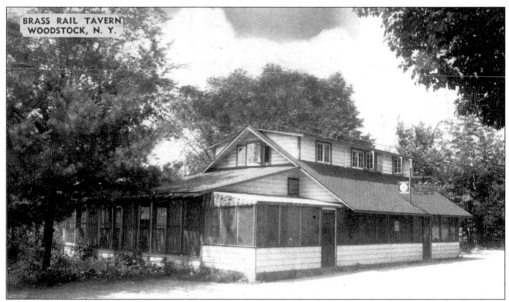

SHANNON'S, BUCKMAN'S, OR THE BRASS RAIL TAVERN. A little farther up the street, on the left, past the site of the Sea Horse and the Colony Art Building is what is known today as the Vasco Pini Frame Shop. In years past, it was one of the places to stop when "making the rounds." It was run at various times by local tavern keepers Deanie Elwyn, Vince Buckman, and Eddy Shannon. (Author's collection.)

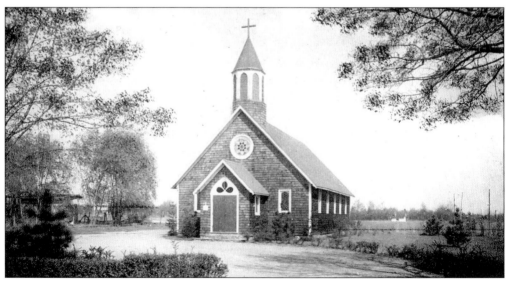

ST. JOAN D'ARC CATHOLIC CHURCH. Just past the main cemetery, within the complex known as the Andy Lee Memorial Field, is the building that was once home to the local Roman Catholic parish. Construction on St. Joan d'Arc Catholic Church began in 1921, and Rev. Peter Spellman said the first Mass on June 25, 1922. (Author's collection.)

THE INTERIOR OF ST. JOAN D' ARC CHURCH. The altar is decorated for the Christmas holiday. The beautiful stained-glass windows and wooden pews were lost when the building was purchased by the town of Woodstock. This structure is now a multipurpose building for the community. (Courtesy Anne Mower.)

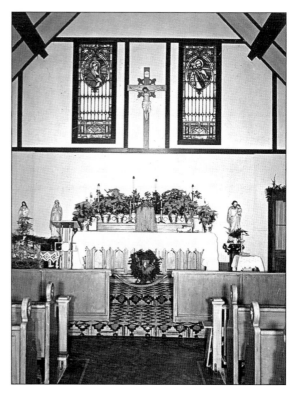

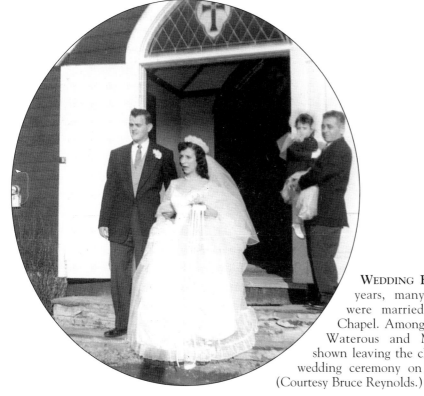

WEDDING BELLS. Over the years, many Woodstockers were married at St. Joan's Chapel. Among them were Bill Waterous and Mary Trippico, shown leaving the chapel after their wedding ceremony on April 2, 1956. (Courtesy Bruce Reynolds.)

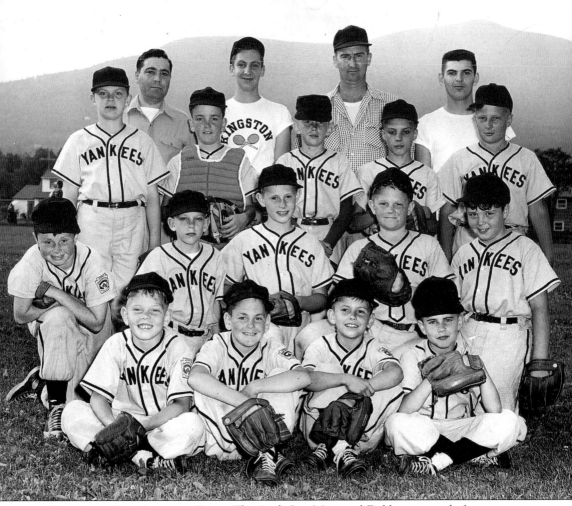

THE ANDY LEE MEMORIAL FIELD. The Andy Lee Memorial Field was named after a young man killed in a shooting accident. Once part of a farm, the field is now the site of many activities, including Little League, adult softball, family picnics, the town recreation program, and ice-skating. Shown are members of the 1957 Woodstock Yankees. From left to right are the following: (first row) Stan Longyear, Ross VanWagenen, John Mower, and ? McClocklan; (second row) Jackie Wilber, Roger Graham, Bob Gordon, Lloyd Gibson, and Roger Phelps; (third row) Dennis Shultis, Jay VanWagenen, Alex Sharpe, Jim Kinns, and Rowan Dordick; (fourth row) ? Di Benedetto, Rudi Hellenschmidt, Bob Hastie, and ? Curry. (Courtesy John Mower.)

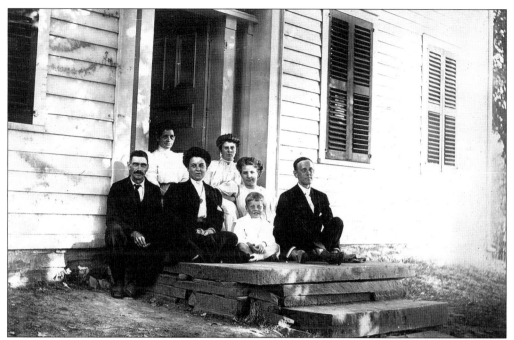

THE ANDREW RISELEY HOMESTEAD, ROCK CITY ROAD. At one time, this family farm stretched all the way up to the California quarry. The young children would be sent to gather in the cows grazing on the pastureland part way up the mountain. Sitting in front of the homestead *c.* 1910, are, from left to right, Walter Beardsmore, O. Herrick, ? Williams, Fred Williams, Ella Riseley, Eva Riseley, and unidentified. (Courtesy Bob Gordon.)

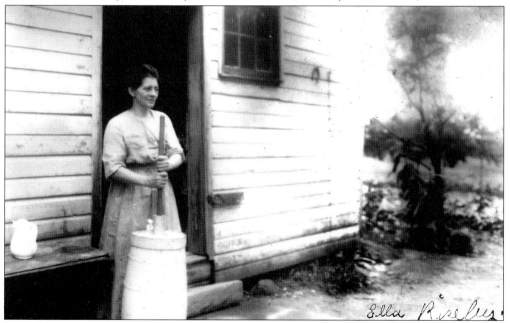

ELLA RISELEY CHURNING BUTTER OUTSIDE THE COOKHOUSE. After Gulick Riseley died, his widow, Ella Riseley, converted the homestead into a boardinghouse and took in summer boarders and artists. (Courtesy Bob Gordon.)

The Andrew Riseley Homestead in Winter. This big farm had its own apple orchards, milk cows, chickens, woodsheds, barns, a cowshed, a granary, and Ella Riseley, who made the very best buckwheat pancakes. The porch was added sometime after 1910. (Courtesy Bob Gordon.)

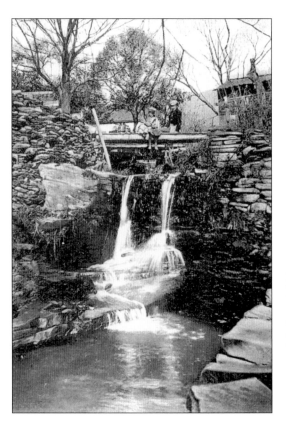

Rock City Corners, East of the Byrdcliffe Art Colony. This intersection was at one time inhabited by quarry workers employed at the California Quarry and in Lewis Hollow. Rosie Magee took in boarders and served meals to the art students. Her gregarious manner added to the flavor of life in the early days of the Woodstock art colony. (Author's collection.)

SUMMER STUDENTS AT THE VILETTA, 1937. Summer students at the Viletta, the boardinghouse at the Byrdcliffe Art Colony, bask in the sun. Founded in 1902 by Bolton Brown, Ralph Whitehead, and Hervy White, the utopian arts and crafts colony was built on farmland with timber from the sawmills of Wittenberg and Mink Hollow. Men who labored to construct the various homes worked under the expert eye of Ford Herrick. (Author's collection.)

LUNCHING ON THE PORCH. Beth Adams, Ruth Davis, and Winnie Davis have lunch on the porch at the Viletta boardinghouse. Ruth Davis was employed by the Whiteheads as cook and housekeeper for students staying at the Viletta. She and her two daughters spent four summers living at Byrdcliffe. (Author's collection.)

THE CARNIOLA, 1937. Part of the Byrdcliffe Art Colony, the Carniola once served as the residence of Bolton Brown, one of the founders of the colony. (Author's collection.)

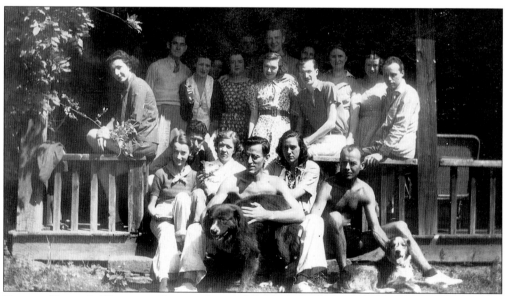

ROBERT ELWYN'S THEATER GROUP. Actors from Robert Elwyn's theater group gather on the porch of the Carniola. Included in the photograph are Hope S. Russell, Nina Partridge, Flo Davis, Francis Bevier, Ted Brooks, Betty Macdonald, Bob Smith, Don Mc Henry, Eleanora ?, Ruth Davis, Velma Rayton, Bob Elwyn, Jimmy Roberts, Tony Volz, Robin Batcheller, Betty Sottler, Frank Rothe, Mike ?, and Bimbo the dog. (Author's collection.)

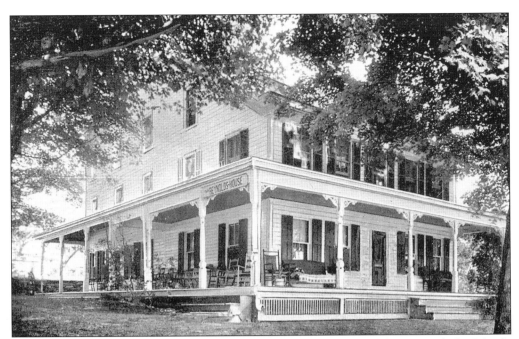

THE REYNOLDS HOUSE, MEAD'S MOUNTAIN ROAD. Will Reynolds managed the Mead's Mountain House and, in 1906, took a turn at managing the Overlook Mountain House. He later decided to go into business for himself and built this boardinghouse. It is located on the east side of Mead's Mountain Road, one mile up from the center of town at one of the very sharp turns. (Author's collection.)

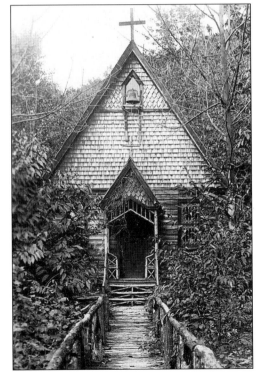

THE CHURCH ON THE MOUNT. To serve summer boarders, the Mead family built this little chapel in the 1890s. Located on a site that was once part of the Chauncy Snyder farm, the Church on the Mount was also used by followers of Father Francis, a bishop of the Old Catholic Church in America. (Author's collection.)

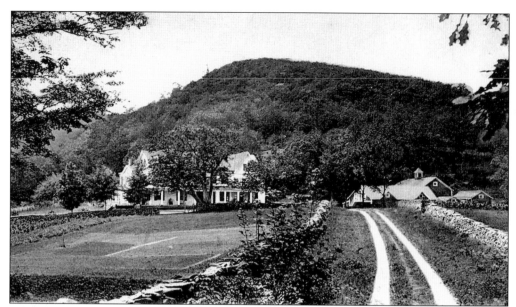

TRAVELING THE ROAD TO MEAD'S. George Mead purchased the site of a halfway house used by travelers on their way up Overlook Mountain and built the Mead's Mountain House in 1865. (Author's collection.)

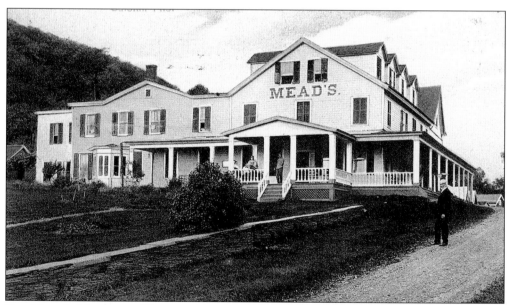

THE MEAD'S MOUNTAIN HOUSE, 1908. At the Mead's Mountain House, guests paid $8 to $10 a week for their room and board, and local girls who worked in the dining room earned $10 a month with board. These interesting facts were noted by Margaret Ruff, writing for the *Kingston Freeman* in 1954. (Author's collection.)

The Cook at the Mead's Mountain House.
When interviewed for a *Kingston Freeman* article,
Mrs. William Mead referred to her cook as "Old
Andrew." Andrew Jackson Banks worked for the
family for over 30 years and was paid about $25
a month. (Author's collection.)

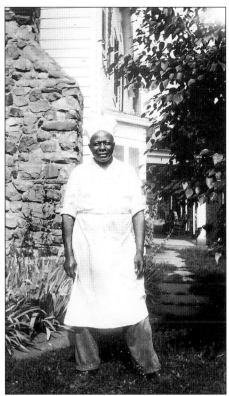

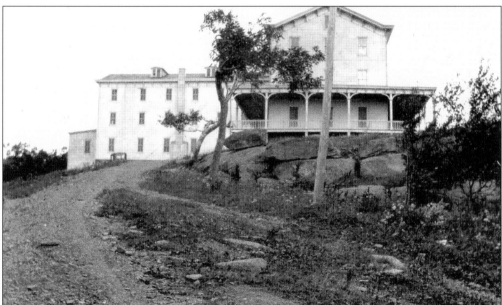

The Overlook Mountain House. Three structures have been built on Overlook Mountain.
This photograph shows the second structure, built by the Kiersted Brothers in 1877. Alf Evers,
writing for the *Kingston Freeman* in 1958, states that "the first Overlook Mountain house
opened in 1871. It was a white 'T' shaped structure of two stories with an additional floor under
a mansard roof covered with colored slates set in a geometric pattern." (Courtesy Jon D. Elwyn.)

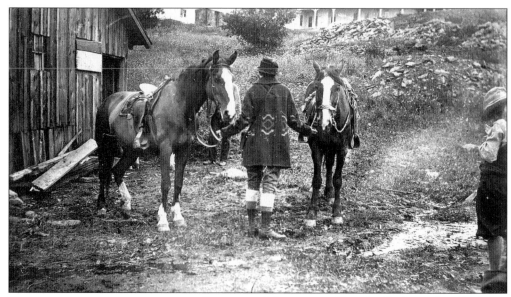

TRANSPORTATION TO THE TOP OF OVERLOOK MOUNTAIN. Dorothy Park steadies Buckskin Nellie and Tom at the barns below the Overlook Mountain House. (Courtesy Harry Park.)

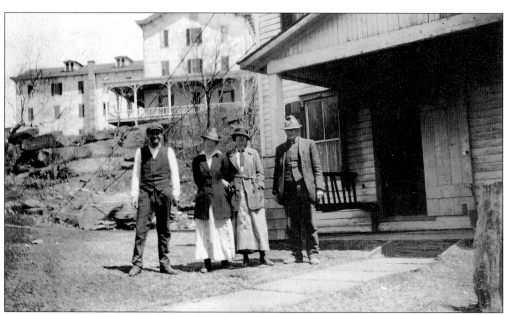

OVERLOOK VISITORS. The three people on the left, Jim Twaddell, Clara Park, and Lucy Thayer, spent the night at the Overlook Mountain House, having traveled there on horseback. The man on the right is the caretaker who lived in the cottage below the house. (Courtesy Harry Park.)

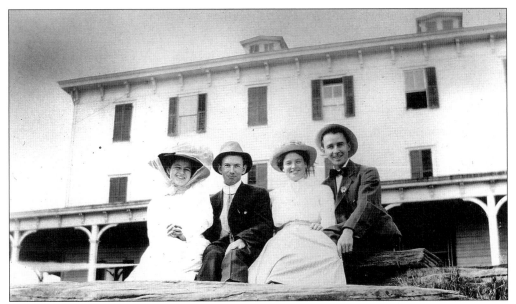

THE SHULTIS LADIES RESTING ON THE PORCH. "The tastes of the day were squarely met with broad porches and with public rooks furnished with highly varnished black walnut chairs, gold framed mirrors and marble topped tables." This description of the Overlook Mountain House, by Alf Evers, appeared in a 1958 edition of the *Kingston Freeman*. (Courtesy Gail Carl.)

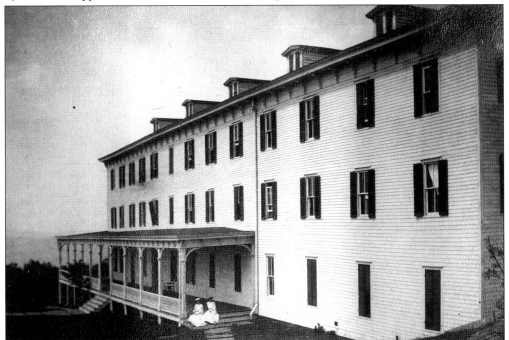

A SUMMER VISIT TO THE OVERLOOK MOUNTAIN HOUSE. Members of the Cramer Shultis family pose on one of the rock ledges near the entrance to the Overlook Mountain House. According to writer Harry Siemsen, "the oldest path on the Overlook Mountain enters the woods nearly west of the hotel and passes the Cold Spring and comes off the mountain near the ruins of the glass factory, built in 1810." (Courtesy Gail Carl.)

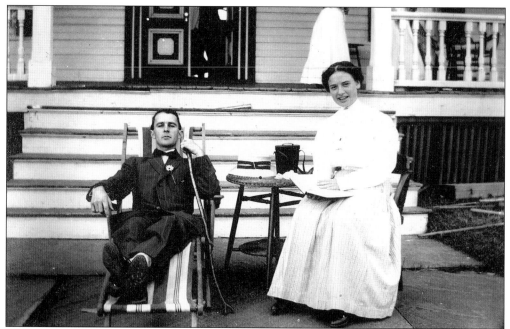

LOUNGING IN FRONT OF THE OVERLOOK MOUNTAIN HOUSE. Members of the Shultis family relax on the patio in front of the main entrance of the Overlook Mountain House. The binoculars are nearby, allowing the hikers to have a closer look at Woodstock village below. (Courtesy Gail Carl.)

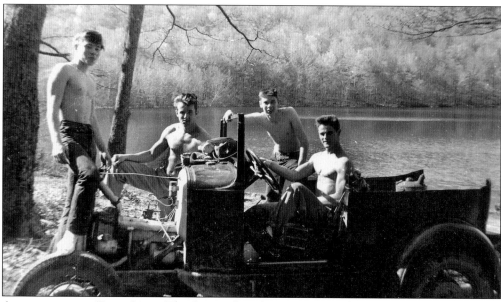

ADVENTURES ON ECHO LAKE. The first road to Shrew's, or Echo, Lake was completed in 1878, coinciding with the opening of the second Overlook Mountain House. Some 80 years later, in 1958, locals and summer visitors continued to explore the nooks and crannies of the mountainside. From left to right are Dave Saar, Robert Foster, Lew Berryan, and Cappy Foster. Local kids would be the first ones up the mountain in early spring and would spend endless hours traversing the Plains, near the glasshouse ruins. (Courtesy Lew Berryan.)

56

Three
SHADY TO WILLOW

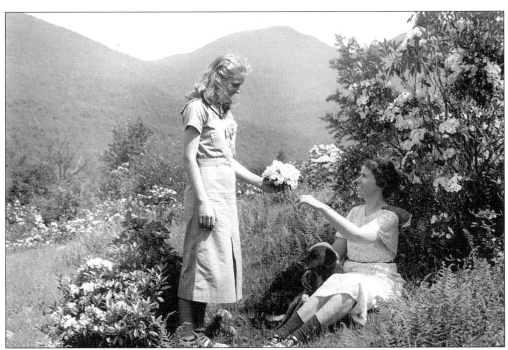

PICKING MOUNTAIN LAUREL IN MEAD'S MEADOW. Winnie Davis (left) and Gen Whitely pose for a German photographer who was staying at the Mead's Mountain House *c.* 1935. Guests could walk north and west on MacDaniel Road, sit on a sunset bench, and watch the evening sun settle over the mountains of Little Shandaken. This pastoral setting is now known as Magic Meadow. (Author's collection.)

INDIAN HEAD, FROM MEAD'S MEADOW. According to Harry Siemsen, town of Kingston historian, "the Indian Head, which is easily lined fifty miles up the Hudson, lies about one mile Northwest of and looks directly down on the Overlook Hotel. It may be visited by following the bridle path to the Plattekill Notch, thence up the Hazard Zig-Zag to the Chin and Nose and the great Mossy Park. The visitor passes over McChesney Ledge between the Twin Towers by the Little Spring, under the eyebrow of the Indian, four thousand feet above the sea and over acres of the most wonderful vermilion and cream colored mosses; the bear trail is everywhere, the views are superb and the whole trip embraces so much interest that none should fail to make it." (Author's collection.)

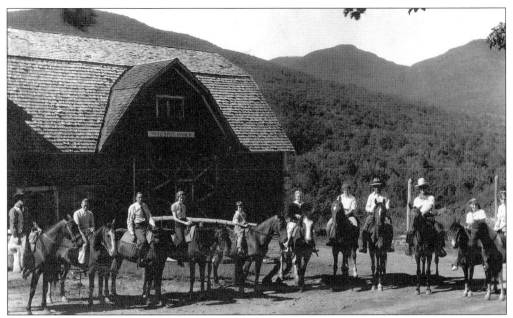

SUMMER BOARDERS AT THE COLD SPRING HOUSE, C. 1930. Art MacDaniel (third from right), family, and guests pose in front of the barn, with Indian Head in the background. The Cold Spring House, a family-run summer boardinghouse, was established in the late 1860s and served boarders well into the 1960s. (Courtesy Harry Park.)

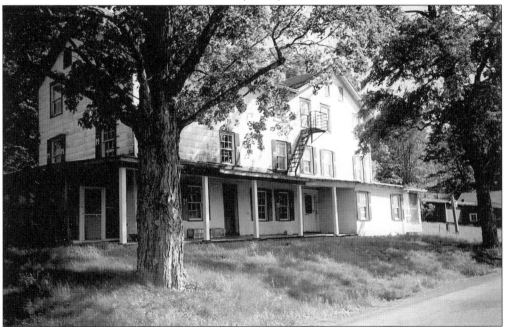

THE COLD SPRING HOUSE. This once magnificent boardinghouse has sadly fallen into disrepair. The wonderful cast-iron stove in the kitchen, large enough to cook meals for 20, also kept everyone warm on the brisk mountain mornings. The lodge, since torn down, had a dance floor, which was used regularly for square dances. The view of Indian Head from the back barn door is breathtaking. (Author's collection.)

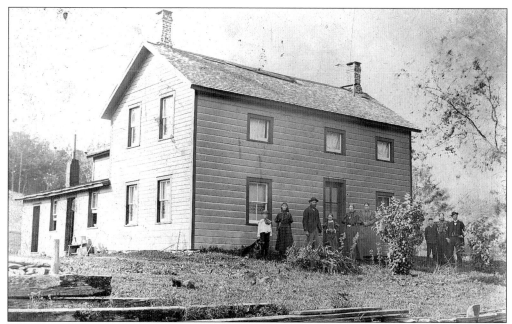

THE KEEFE HOLLOW HOMESTEAD. After the Civil War, members of the Keefe family established their homestead in a beautiful valley along the Sawkill, on land previously traveled by glass factory workers. (Courtesy Harley Avery.)

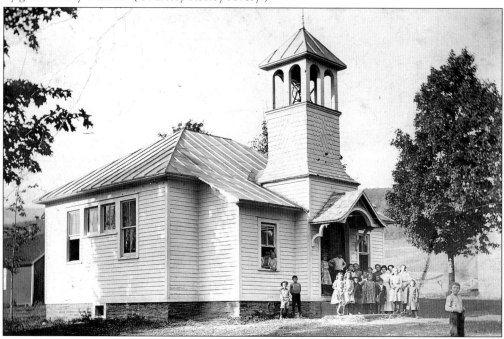

THE SHADY SCHOOLHOUSE. The New York State legislature established seven common school districts in Woodstock *c.* 1815. Thus, until the Onteora district was established in the 1950s, children from Shady attended school here. The Shady Methodist Church stands next to the little school building and has a hall and old carriage sheds located behind it. The Shady Ladies continue a favorite tradition: the church supper. (Courtesy Donna VanDeBogart Stoutenberg.)

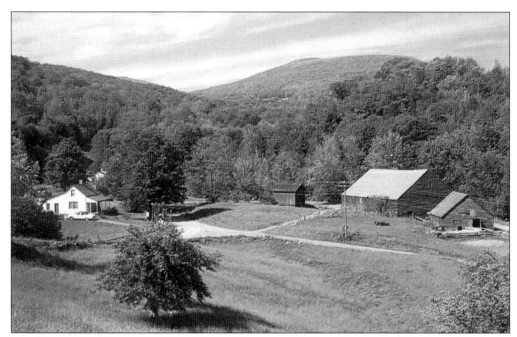

THE REYNOLDS HOUSE AND THE GLASS FACTORY BARNS. Members of the Reynolds family have traced their lineage back to England in the 1500s. The first Reynolds descendant came to Woodstock in the late 1700s. The crossroads area pictured was once called Bristol and, between 1815 and 1840, it served as the hub for the glass industry in Woodstock. (Author's collection.)

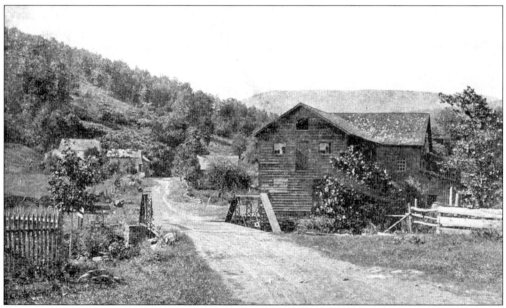

THE GRISTMILL, 1905. This building stands on Route 212, just past the first bridge west of the Glasco Turnpike intersection. Glasco Turnpike was used by the glass company workers to transport their products to the docks in Saugerties. From there, the Bristol glass was shipped via the Hudson River to markets in New York City. (Author's collection.)

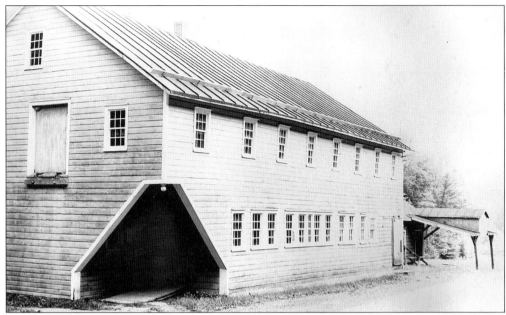

THE VOSBURGH-STONE TURNING MILL. Richard and Polly Roe Vosburgh settled in Bristol to work in the glass factory. Their sons James and Albert Vosburgh first operated the water-powered wood turning mill in 1860. With the help of their grandson Craig Vosburgh and his son-in-law Arthur Stone, the mill continued in operation through 1959. (Courtesy Evelyn Stone.)

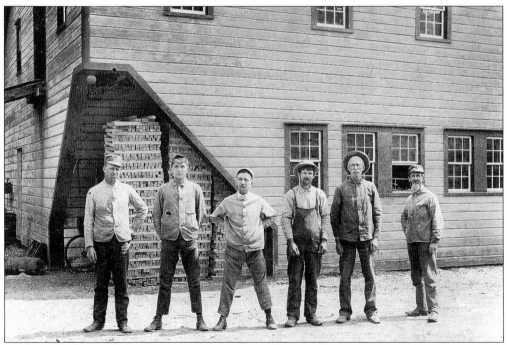

MILL WORKERS IN SHADY. Local men pose in front of stacked wood, which is ready to be turned into table legs. Among them are John Sickler and Van Howland (fifth and sixth from the left). (Courtesy Sondra Sickler Shultis.)

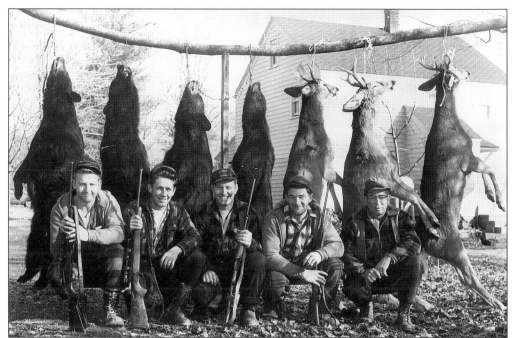

A SUCCESSFUL HUNT, 1967. After a good day, five hunters pose with their trophies in front of the Chase home on Route 212 in Lake Hill. From left to right are Howard Shultis, Aaron VandeBogart, Lenny Sperl, Chippy Chase, and Junior VanDeBogart. Deeply rooted in Woodstock, each of these men knows the hills and valleys of Shady, Lake Hill, and Wittenberg like the back of his hands. (Courtesy Donna VanDeBogart Stoutenberg.)

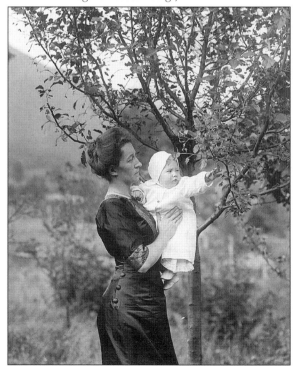

IN THE ORCHARDS, 1913. In the summer of 1913, Mabel Crane VandeBogart and her son Aaron VandeBogart pose for a professional photographer in the orchards of the VandeBogart homestead, at the end of Harmati Lane in Shady. (Courtesy Donna VanDeBogart Stoutenberg.)

63

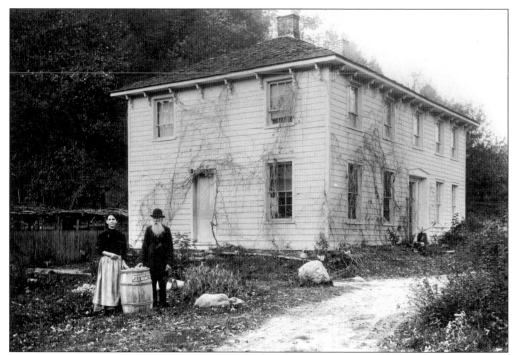

THE HOWLAND HOMESTEAD, MINK HOLLOW ROAD. Sarah Emma Quick, who was born in 1856, and Hiram Howland, who was born in 1839, were married on September 9, 1871. The Howlands established their farm in Mink Hollow *c.* 1860. Many of their children were brought into the world in the "borning room" upstairs. The house sits on the left side of Mink Hollow Road, about one and a half miles in. (Courtesy Bruce Smith.)

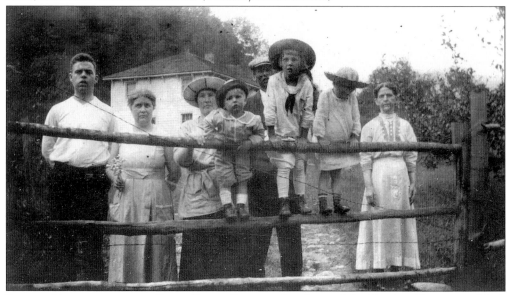

SAYING GOOD-BYE AT THE GATE. Farewells are said in front of the Howland house, on Mink Hollow Road. From left to right are Maynard Smith, Mira Howland Smith, Beatrice Howland Keefe, Maynard Keefe, Herbert Keefe, Jeanette Keefe, Pauline Keefe, and Sarah Quick Howland, the grandmother. (Courtesy Bruce Smith.)

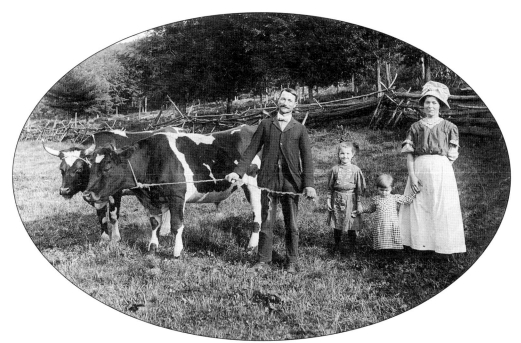

THE SICKLER FAMILY OF MINK HOLLOW. Members of the Sickler family pose for this photograph, taken by John Sickler. Their proud smiles may be attributed to the purchase of the two oxen, which will help papa with the plowing. For the farmer, oxen were less trouble than horses, which tended to be skittish and to startle easily and gallop away. (Courtesy Sondra Shultis Sickler.)

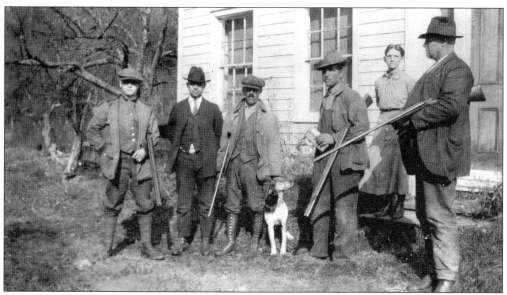

DRESSED FOR A DAY IN THE WOODS. Heading off from the Howland house in search of bear, deer, or panther are, from left to right, ? Gifford, Bob Gifford, Maynard Smith and his hunting dog, Lionel ? (uncle), Sarah Quick Howland (grandmother), and Oscar Howland. (Courtesy Bruce Smith.)

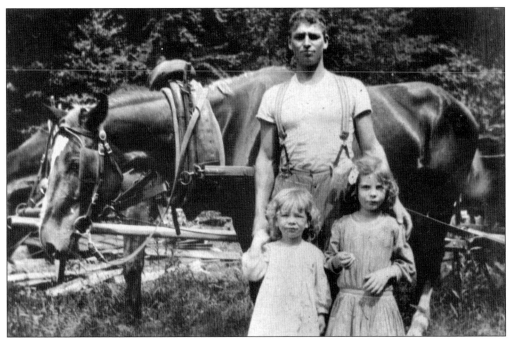

THE WILBERS AT THE DALEY RANCH. Pictured at the Daley Ranch are Harry Wilber and his children Richard and Clara Wilber. The son of Samuel G. Wilber, Harry Wilber met his wife when they both worked for the Daleys. He worked for the dentist Dr. Daley, and Kathleen Matchett, who came to America from Ireland, worked as a housekeeper for the Daleys, traveling with them to their summer home in Mink Hollow. (Courtesy Casey Drake.)

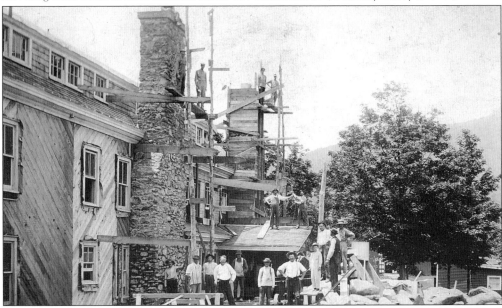

BUILDING A FIREPLACE AND CHIMNEY AT THE DALEY RANCH. The large three-story building on Mink Hollow Road had two large fireplaces. The nearby streambed supplied ample stone for the project. This property later became a dude ranch known as the Rawhide Ranch. (Courtesy Sondra Sickler Shultis.)

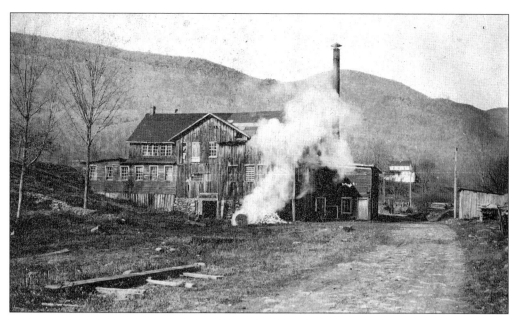

ONE OF THE WILBER SAWMILLS, MINK HOLLOW. This mill stood on the left side of the road, just before the turnaround. Samuel, Abram, and Rufus operated the Wilber Brothers Sawmills in Mink Hollow. The house in the back was known as the Crane house. Abram Wilber later moved into Woodstock and set up a mill on the Sawkill just above Dan Sully's mill. (Courtesy Lorraine Elliot.)

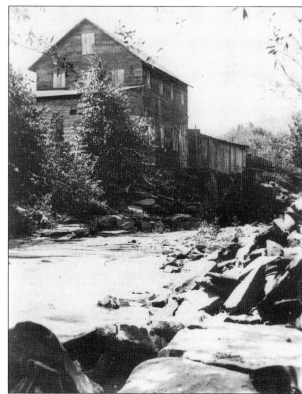

THE MILL AT THE END OF MINK HOLLOW. The ruins of the foundation for this turning mill are barely visible in 2002. The crumbling remnants tell of a hardworking community, known for its large families, summer boarders, square dances, and talented wood turners. (Courtesy Historical Society of Woodstock.)

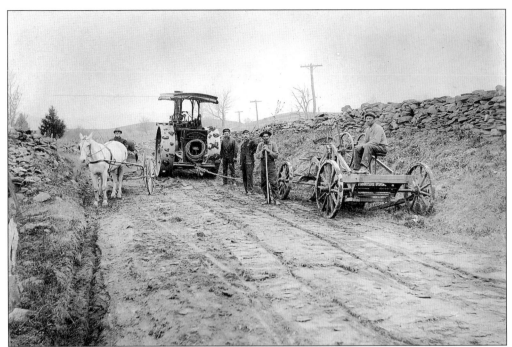

THE CONSTRUCTION OF SICKLER ROAD. Mathias Sickler drives his horse and buggy past the road crew stalled in the mud on Cooper Hill. At one time, Sickler Road went around the back of Cooper Lake. Once the Lasher farm was flooded, the main road moved to where Route 212 is today. (Courtesy Sondra Sickler Shultis.)

DELIVERING MAIL IN LAKE HILL. The postman carries a sack labeled U.S. Mail. In 1896, the federal government established rural free delivery (RFD). Each little hamlet had its own post office. Many local addresses remained RFD well into the 1980s. (Courtesy Sondra Sickler Shultis.)

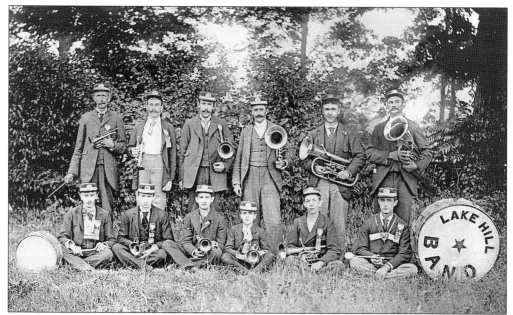

THE LAKE HILL BAND, SEPTEMBER 15, 1897. The Lake Hill Band played at picnics and dances throughout the area from Woodstock to Shandaken. Band members are, from left to right, as follows: (front row) R.E. Wilber, snare drum; W.H. Wilber, G.E. Wilber, Gordon Sickler, and Emil Howland, all B-flat coronet; and Perry Mosher, bass drum; (back row) John Sickler, leader; Fred Drennon and Arthur Bard, both alto; Fred Broadil, baritone; Charles Davis, tenor; and Merritt Staple, bass. (Courtesy Sondra Sickler Shultis.)

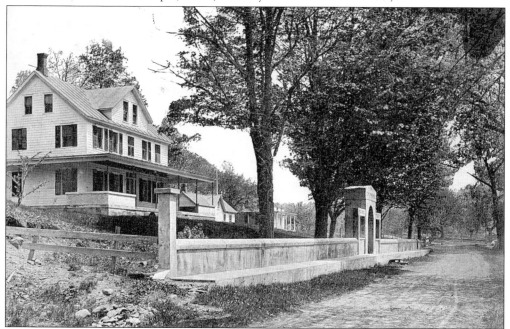

THE HOME BEYOND THE FIREHOUSE. Once the residence of J. Wagoner, this home was at another time a tavern known as Joleen's. The building is located on Route 212, just west of the firehouse. (Author's collection.)

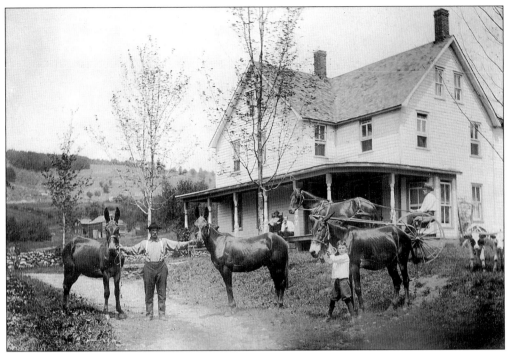

THE QUICK HOMESTEAD, WILLOW. Great Grandpa Quick has help moving the livestock around. Mules, although considered stubborn, were preferred because of their surefootedness and hardiness. (Courtesy Sondra Sickler Shultis.)

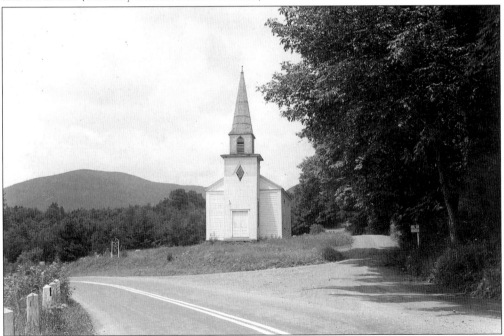

THE WILLOW WESLEYAN CHURCH. The Willow Wesleyan Church and its cemetery stand at the intersection of Ostrander Road and Route 212, west of the Wittenberg Road junction. (Courtesy Donna VanDeBogart Stoutenberg.)

Four

WITTENBERG
TO BEARSVILLE

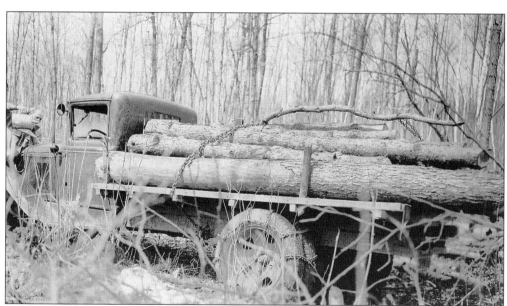

FILLING THE GAS TANK. Bjarne Sjursen fills the gas tank on the log truck. According to writer-historian Alf Evers, "as early as 1802, a report was made to Chancellor Livingston that progress was being made on the Turnpike going through the Hurley Woods and Yanky Town, over the Cannenbergh at Big Shandaken." The turnpike became the main roadway to and from the Colonial town of Kingston. The region's main resources were water and timber and, at one time, there were more than 100 mills tucked away in these mountains. (Courtesy Ole Sjursen.)

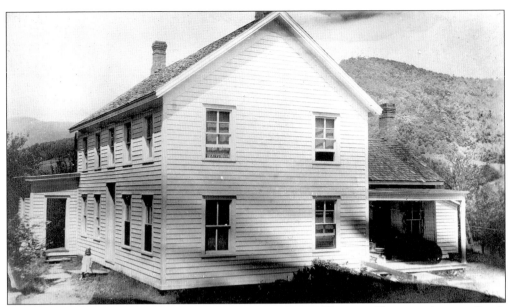

THE SHERMAN SHORT HOMESTEAD, WITTENBERG ROAD. Sherman Short was born in South Woodstock, and he and his father, Alfred Short, built a sawmill behind the house in 1903. The family had apple orchards, hayfields, and produced lumber used for apple barrels. During the Revolutionary War, Sherman Short's great-grandfather Petrus Short was captured by the Tories while traveling on the Woodstock–Saugerties road about half a mile from the Zena intersection. (Courtesy Bruce Reynolds.)

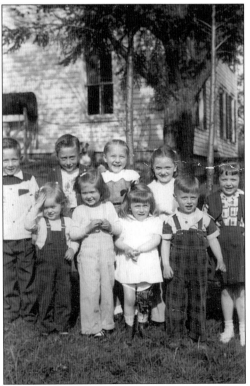

OUTSIDE THE ELIAS SHORT-VANDEBOGART HOUSE. Born in this house in 1795, Elias Short served in the War of 1812. He was part of a group of three men accused of trespassing on Livingston land for the purpose of stealing oak bark. From left to right are Sandy Crotty, Beverly Crotty, Donna VanDeBogart, two unidentified persons, Brian Angevine, Viola Gardner, Anita Gilsinger, and unidentified. (Courtesy Donna VanDeBogart Stoutenberg.)

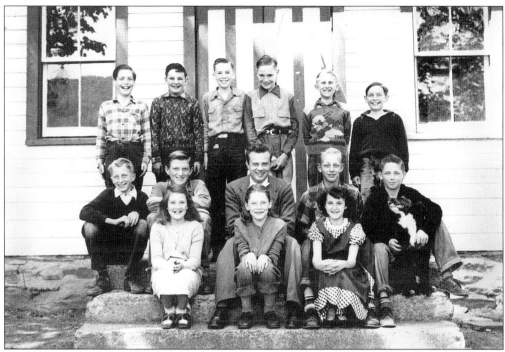

THE WITTENBERG SCHOOL'S SEVENTH-GRADE CLASS, 1952. The little red schoolhouse stood just to the west of the church carriage sheds. From left to right are the following: (front row) Joyce VanDeBogart, Sylvia VanDeBogart, and Bobbi Elting; (middle row) Ole Sjursen, Lester Shultis, Vince Carey, Jim Shultis, and Aaron VanDeBogart; (back row) Peter Schlemowitz, Frank Van Wagoner, Ralph Bonesteel, Kenneth May, Roger Schribner, and Jerry Schlemowitz. (Courtesy Donna VanDeBogart Stoughtenberg.)

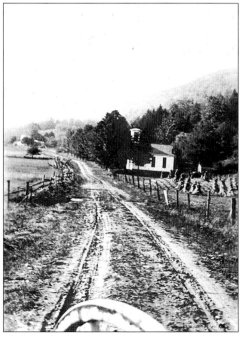

THE METHODIST EPISCOPAL CHURCH, WITTENBERG ROAD. People still talk about the annual church suppers held during the summer at the Woodstock Methodist Episcopal Church. This one-lane dirt road was known as the Ulster and Delaware Turnpike, the main thoroughfare to the Rondout Docks in Kingston in the 18th and 19th centuries. Although some sections went unpaved until the 1950s, crushed stone was laid down when Sherman Short served as highway superintendent. (Courtesy Bruce Reynolds.)

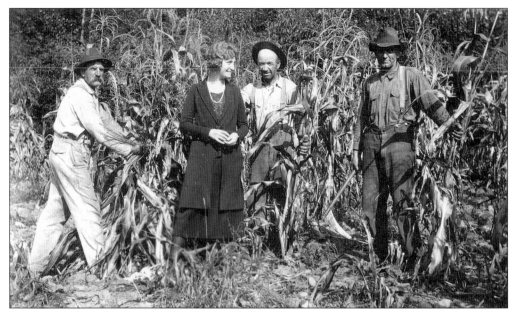

PLAYING IN THE CORNFIELD. The Riseley family often sent a car to the Coldbrook or the West Hurley train station to transport boarders back to the homestead, located on the corner of Coldbrook and Wittenberg Roads. From left to right are two unidentified boarders, Watson Riseley, and Joe Buda, a hired hand. (Courtesy Velma Grazier.)

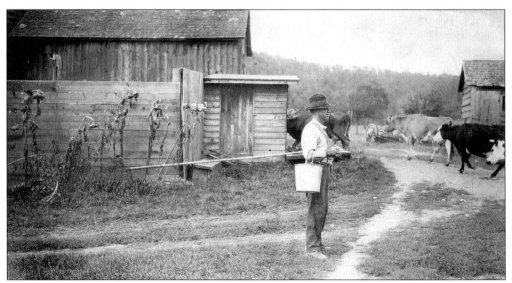

BRINGING THE COWS IN FOR MILKING. Watson Riseley waits with the milk pail in the crook of his arm while the cows move into the milk barn. It must have been a dry summer, as the sunflowers behind Cashdollar look like they need water. (Courtesy Velma Grazier.)

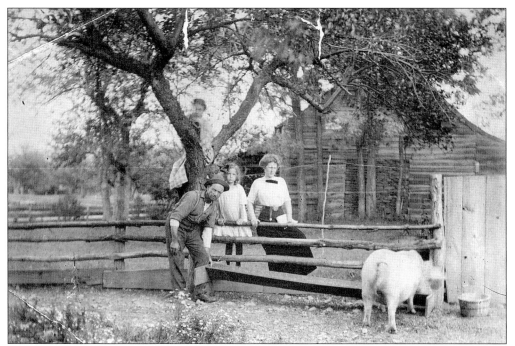

POSING IN FRONT OF THE SLAB HOUSE. The slab house, known as the Alfred Gulneck house, stood at the intersection of Wittenberg and Coldbrook Roads. The Gulneck family first appears on the 1850 census. Identified in this picture are Watson Riseley, holding the trough while Mr. Piggy enjoys his supper, and Loudora Riseley, in the tree. (Courtesy Velma Grazier.)

THE GULNECK-RISELEY FARMHOUSE. A new house was constructed behind the old slab dwelling *c.* 1900. The new house incorporated chestnut timbers from the old dwelling, as well as some doors and windows from homes destroyed when the Ashokan Dam was built. (Courtesy Velma Grazier.)

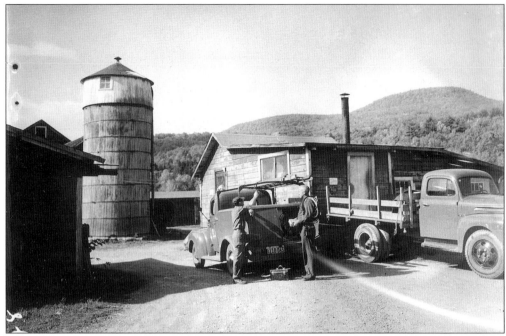

THE LOCUST GROVE DAIRY. Everett Cashdollar (left) and Mervin Doremus plan their day in front of the milk house on West Wittenberg Road. The Riseley-Cashdollar dairy farm included a livestock barn, silo, calve pen, hay barn, horse barn, icehouse, bull pen, carriage shed, and corncrib. Almost all these buildings have been demolished. (Courtesy Velma Grazier.)

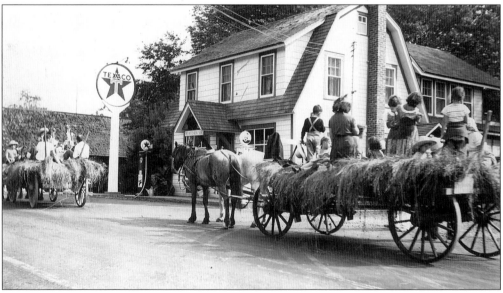

THE WITTENBERG STORE. Floyd Stone and his wife, Vera Shultis Stone, first ran the store in the 1920s. It remains as one of two Woodstock hamlet food stores that continue to operate today. At one time, customers could buy meat, dairy, and dry good products, as well as gather around the counter and share local bits of information. The Texaco pumps were removed long ago, along with the remnants of the sawmill that stood next to the store. A hayride passes by. (Courtesy Ned Houst.)

LIFE ON THE WITTENBERG–GLENFORD ROAD. Not all Woodstock residents are descended from the Palatine or English emigrants. With the prospects of work very dim in his native Norway, Bjarne Sjursen came to America in 1919 and found work with Dr. Rugg in Bearsville. From left to right are the following: (front row) Eddie Sjursen; (back row) Marie and Bjarne Sjursen, Irene Sjursen, and Ole Sjursen. (Courtesy Ole Sjursen.)

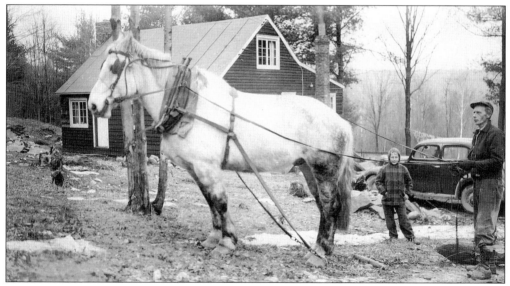

LINING UP THE HORSE WITH THE SLED. Bjarne Sjursen carefully harnesses his horse in preparation for the day's work. He and his wife, Marie Sjursen, had plenty of opportunities to socialize with fellow Norwegians. He could ride his horse cross lots and visit with the Norwegian colony that had formed atop Yerry Hill, near Montoma. (Courtesy Ole Sjursen.)

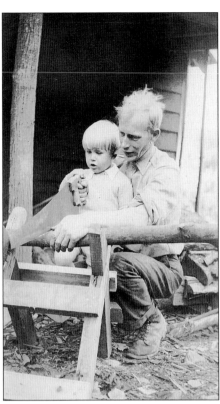

LEARNING HOW TO CUT LOGS AT AN EARLY AGE. Living in Wittenberg, one needed to know how to use a saw safely. Bjarne Sjursen instructs his young son Ole Sjursen on the use of a single-hand saw. (Courtesy Ole Sjursen.)

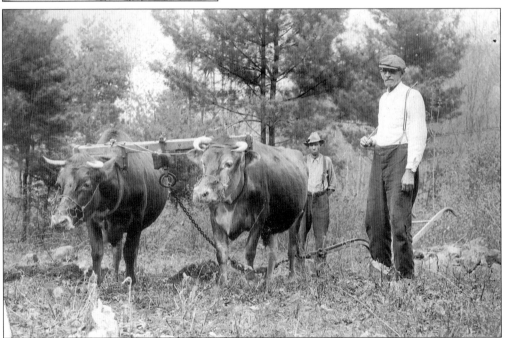

LEANDER BONESTEEL WITH HIS OXEN. Leander Bonesteel uses his oxen to plow his fields in the spring. In his right hand, he holds a switch, a simple device to assist in directing the oxen on their path. (Courtesy Ole Sjursen.)

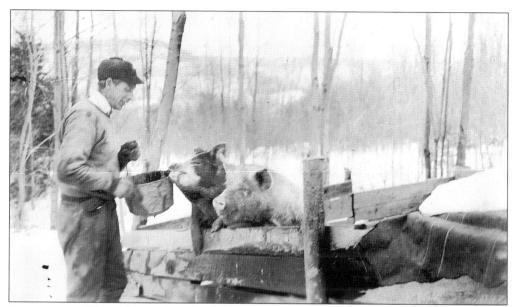

FEEDING THE HOGS. Many Woodstock families who lived on farms could be self-sufficient. They produced their own milk, eggs, butter, ice cream, processed meats, dried food, and meat. Bjarne Sjursen is pictured feeding his hogs. (Courtesy Ole Sjursen.)

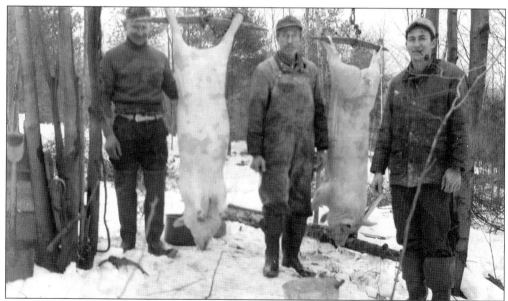

PREPARING THE HOGS FOR SLAUGHTER. Local men would go from farm to farm and assist one another with the butchering. From left to right are Chester Shultis, Harry Bonesteel, and August May, suited up on a snowy day at the farm on the Wittenberg–Glenford Road. (Courtesy Ole Sjursen.)

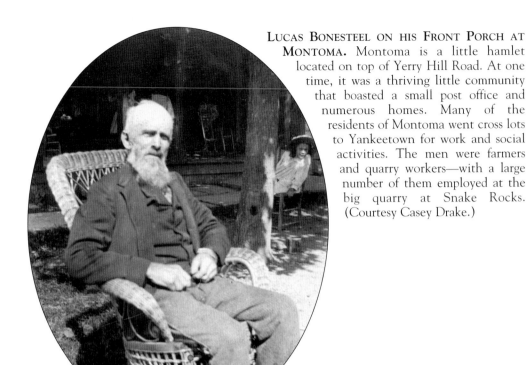

LUCAS BONESTEEL ON HIS FRONT PORCH AT MONTOMA. Montoma is a little hamlet located on top of Yerry Hill Road. At one time, it was a thriving little community that boasted a small post office and numerous homes. Many of the residents of Montoma went cross lots to Yankeetown for work and social activities. The men were farmers and quarry workers—with a large number of them employed at the big quarry at Snake Rocks. (Courtesy Casey Drake.)

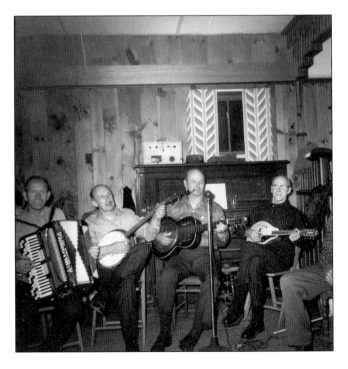

THE WITTENBERG SPORTSMAN'S CLUB. At one time, the Wittenberg Sportsman's Club hosted many square dances and pork dinners. Playing music at the club are, from left to right, Bjarne Sjursen, Bob Dubois, unidentifed, and Carlton Hoyt. The club has preserved acres of land in Wittenberg that can be used by members for hunting. (Courtesy Ole Sjursen.)

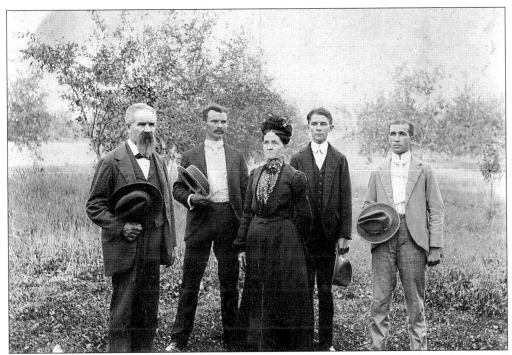

FIVE MEMBERS OF THE SHULTIS FAMILY. With his sons, Cramer Shultis (left) ran the sawmill located across the Wittenberg Road from the family homestead. Pictured with Shultis are, from left to right, his son Bert, his wife, Elizabeth Stone Shultis, and his sons Willie and Oakley. Not pictured are six daughters and another son. (Courtesy Gail Carl.)

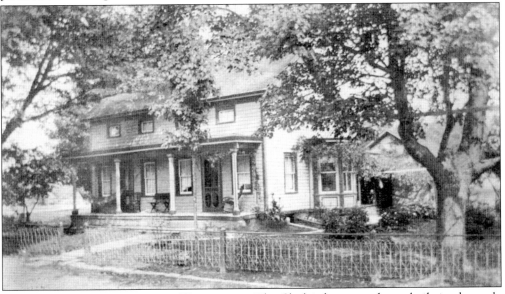

THE CRAMER SHULTIS FAMILY HOMESTEAD. The Shultis homestead was built in the early 1860s to accommodate a growing family. It is located along what was the Ulster and Delaware Turnpike, where drovers once herded cattle, sheep, and turkey into the nearby fields to rest overnight on their journey to the Rondout Docks. Cramer Shultis is the great-grandnephew of Henry P. Shultis, who was the Woodstock agent for Robert L. Livingston. (Courtesy Gail Carl.)

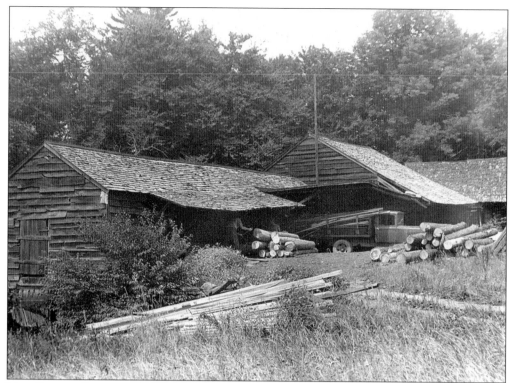

THE CRAMER SHULTIS AND SONS SAWMILL. The Shultis sawmill, built in the late 1800s, stood to the east of the Wittenberg Store. Behind the water-powered mill were the sluiceways, the millpond, and an icehouse. (Courtesy Gail Carl.)

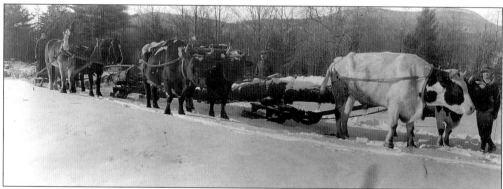

BRINGING LOGS OUT OF THE WOODS. Oxen and horse teams haul logs on sleds *c.* the late 1940s. Sleds were used when the ground was frozen, lessening the chance of getting stuck in the soft earth. The stand of trees was often miles into the woods, and the men would have to walk through hip-deep snow, with only long johns and wool pants to protect them from the cold. (Courtesy Gail Carl.)

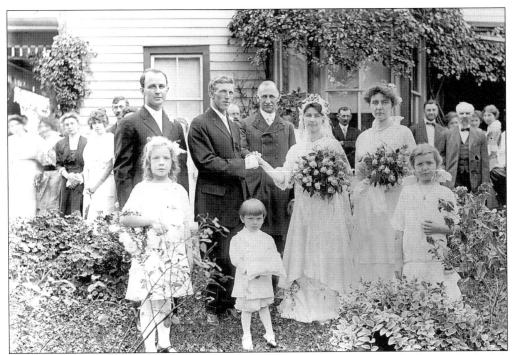

EVA SHULTIS AND EVERAND SHORT'S WEDDING DAY. This wedding took place at the bride's home at the intersection of Wittenberg, Bearsville, and Glenford Roads on September 9, 1914. The three children in the foreground are unidentified family members. From left to right are Oakley Shultis, Everand Short, an unidentified minister, Eva Shultis, and sister of the bride Alice Shultis Winnie. In the background on the right is Cramer Shultis (with beard). Everand Short was postmaster at Wittenberg and Woodstock tax collector. (Courtesy Gail Carl.)

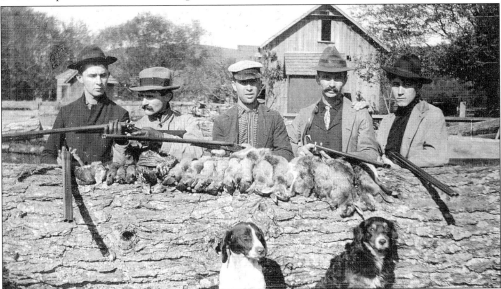

AFTER THE HUNT. With their trusty hunting dogs standing guard in front of the large log, these Wittenberg men have at least two dozen rabbits to show for their day in the woods. Besides hunting rabbits, they also trapped muskrat, beaver, and mink. (Courtesy Gail Carl.)

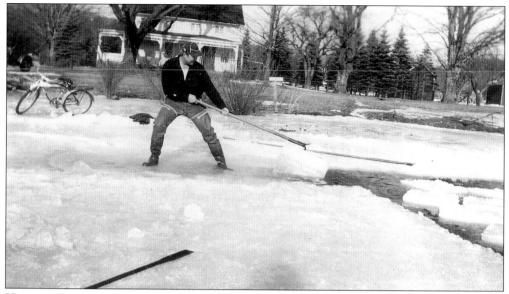

HAULING ICE OUT OF THE MILLPOND. In March 1952, Nelson Shultis pulls on a block of ice. The Cramer Shultis homestead is in the background. (Courtesy Gail Carl.)

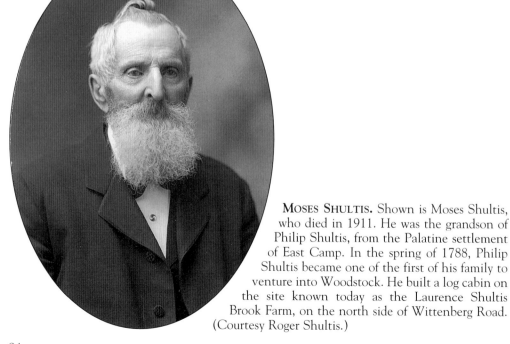

MOSES SHULTIS. Shown is Moses Shultis, who died in 1911. He was the grandson of Philip Shultis, from the Palatine settlement of East Camp. In the spring of 1788, Philip Shultis became one of the first of his family to venture into Woodstock. He built a log cabin on the site known today as the Laurence Shultis Brook Farm, on the north side of Wittenberg Road. (Courtesy Roger Shultis.)

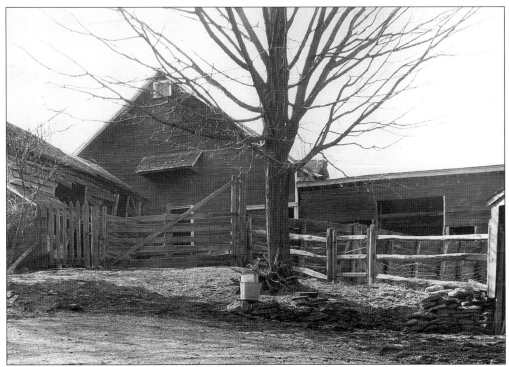

THE BARNS AT THE SHULTIS FARM. The Laurence Shultis homestead was built in the early 1800s and was the home of Henry P. Shultis, the Livingston agent. It once served as the gathering place for members of the Woodstock Methodist Episcopal Church. (Courtesy Roger Shultis.)

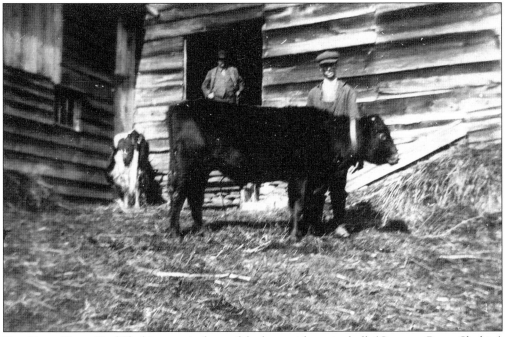

THE PRIZE BULL. Fred Shultis poses in front of the barn with a prize bull. (Courtesy Roger Shultis.)

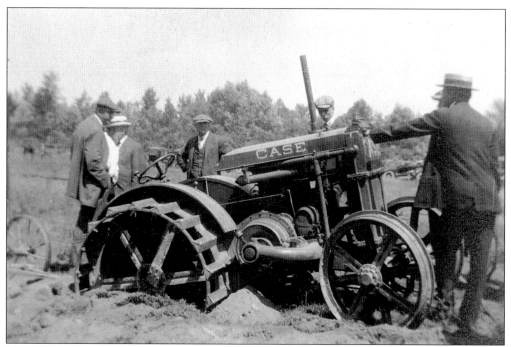

NOT EVERY DAY ON THE FARM IS EASY. Members of the Shultis family ponder the best course of action for extracting the Case tractor from the mud. (Courtesy Roger Shultis.)

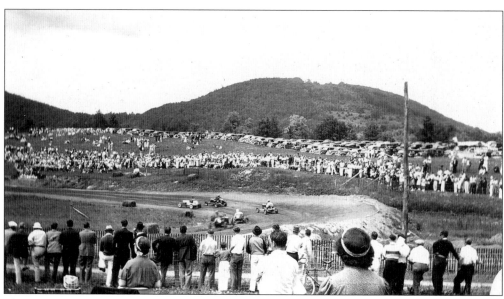

MIDGET AUTO RACES. Woodstock Legion Speedway issued capital stock in 1938. The track was located on Race Track Road in Bearsville. (Courtesy John Mower.)

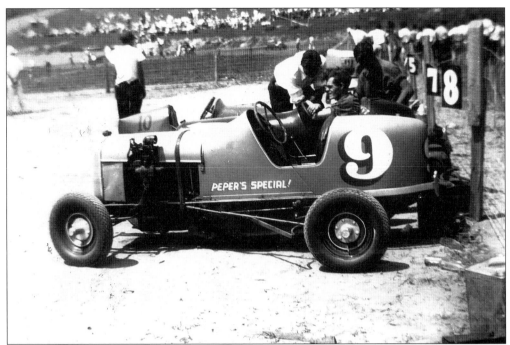

PEPER'S SPECIAL. Unidentified men in the background work on midget car No. 10 while No. 9 nine awaits its driver. The track could accommodate up to 40 cars per race. Drivers came from as far away as Massachusetts and Connecticut to compete at the speedway. (Courtesy Jim Kinns.)

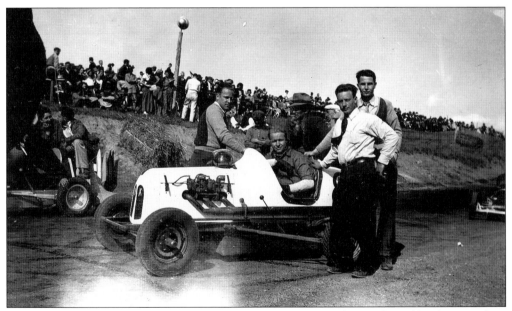

MIDGET CAR NO. 8. Posing with their car are, from left to right, Fred Markle, driver Nelson Shultis, race organizer Ken Van Wagner, and Chick Bailey. Youngsters would wait by the roadside to watch the competing cars roll up Mill Hill Road. (Courtesy Jim Kinns.)

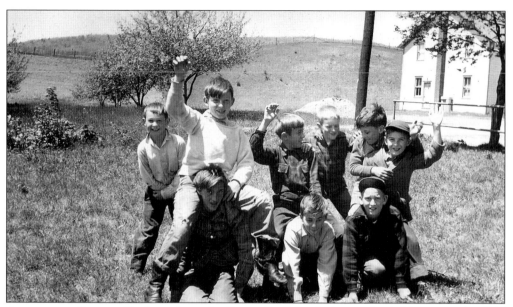

AFTERNOON RECESS. Students from the Bearsville School play in the field next to the Odd Fellows Hall in May 1948. From left to right are the following: (front row) Ward Berryann, Jay Peterson, and Dayton Shultis; (back row) Coxy Mellin, John Boswell, Wallace Klitgaard, Eddie Gilligan, Robert Schebislki, and Vernon Shultis. (Courtesy Roger Shultis.)

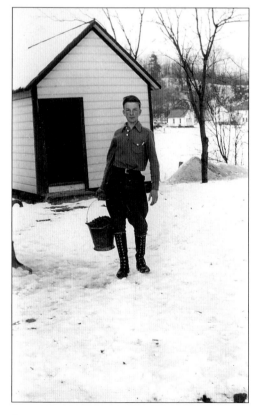

FILLING THE COAL STOVE. Each one-room school had its own maintenance committee responsible for the physical upkeep of the building. The day-to-day operations fell to the teacher and capable students. Roger Shultis carries a loaded coal scuttle in from the coalbin. (Courtesy Elsie Shultis.)

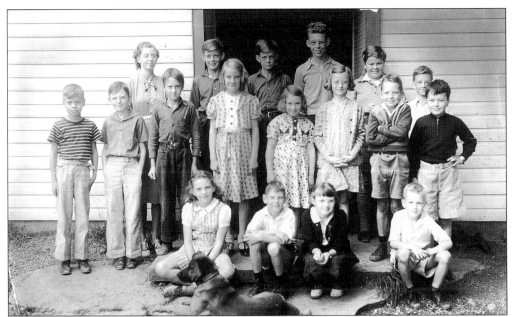

BEARSVILLE SCHOOL STUDENTS. Students at the Bearsville School *c.* 1940 are, from left to right, as follows: (first row) Jackline Frankling, Donald Downer, Ann Grasier, and Richard Shultis; (second row) Joan Shultis, Ann Reynolds, Paul Downer, and Paul Grasier; (third row) Arnold Reynolds, Gordon Reynolds, Robert Reynolds, and Elsie Shultis; (fourth row) Evelyn Stone, Durand Rose, Donald Rose, Calvin MacDaniel, Bruce Walker, and Roger Shultis. (Courtesy Elsie Shultis.)

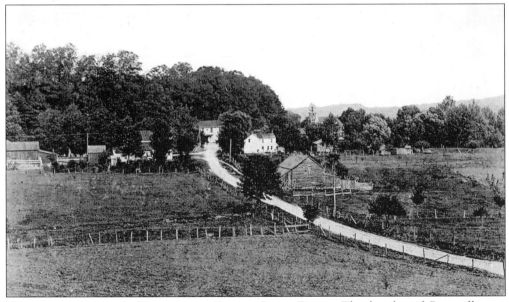

BEARSVILLE, LOOKING EAST FROM COOPER LAKE ROAD. The hamlet of Bearsville was established at the corner of the Bearsville and Wittenberg Roads. It is named after Christian Baehr, a German emigrant who purchased land where the now defunct glass factories had been. The residents of the area were served by a school, a store and post office, and a gas station at one time. (Author's collection.)

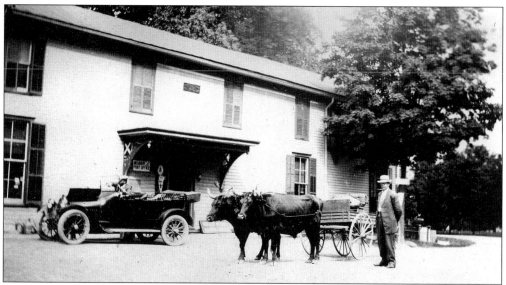

THE BEARSVILLE STORE. The store and post office were once located in the building now known as the Bearsville Apartments. The man with his oxen and cart was to soon find his mode of transportation changed to the four-wheeled, gas-powered motorcar. (Courtesy the Marie Raymond collection, Historical Society of Woodstock.)

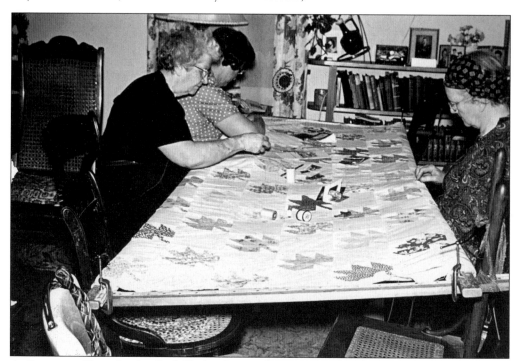

A QUILTING BEE. At the Fred Shultis home, three women hand quilt on a portable frame. From left to right are Elizabeth Shultis, wife of Gus Shultis; Ethel DeGraff, wife of Clyde DeGraff; and Lottie Shultis, wife of Fred Shultis. Many girls learned to quilt at a young age and were able to produce everyday utility quilts out of old material or new quilts to be given as gifts. Occasionally, handmade quilts could be bought at the church fairs. (Courtesy Gail Bonestell.)

Five

BEARSVILLE FLATS TO WOODSTOCK CENTER

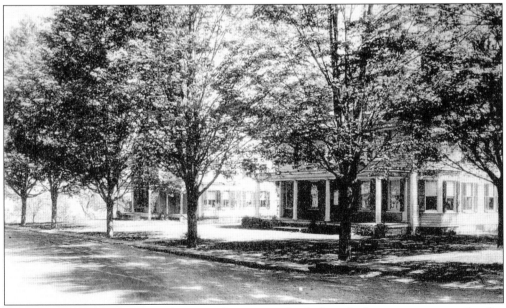

THE BEARSVILLE CORNERS. These two homes stood side by side for many years until a fire destroyed the one on the left. The one on the right, known as the Peterson House, is occasionally open as a restaurant and is part of the Bearsville Theatre-Restaurant complex. (Courtesy Harry Park.)

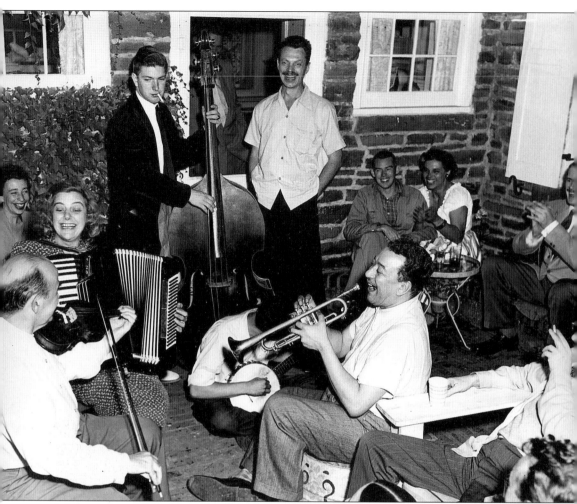

A MUSIC SESSION AT FAIRFIELDS, C. 1940. This estate house is located on Strieble Road in Bearsville. Holding a music session at Fairfields are, from left to right, John Strieble on violin, John Pike on banjo, Bill Moore, Mac McCarthy, Marge Huffine Strieble, Clem Nessel on accordion, Victor Allen on bass, Dave Huffine, unidentifed, and Margot Cramer. (Courtesy Victor Allen.)

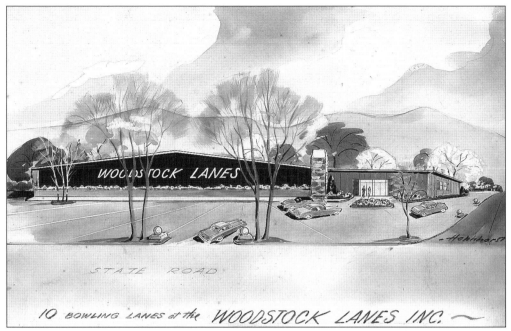

THE WOODSTOCK LANES. In 1959, the Kennedy-Allen family opened Woodstock Lanes on land once owned by the Elwyns. The bowling alley began with 10 lanes and was later expanded to 14 lanes. By 1962, it was in full swing, with a snack shop and leagues four nights a week and Saturday mornings. Local artist Harry Hornhorst prepared this view of Woodstock Lanes prior to its opening. (Courtesy Victor Allen.)

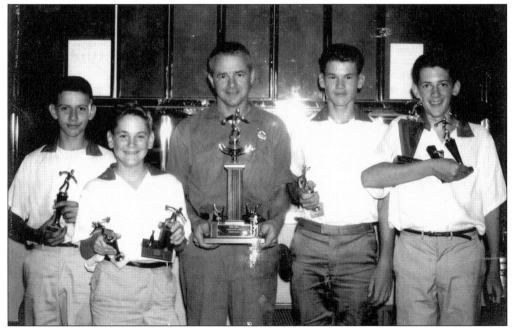

WOODSTOCK LANES JUNIOR CHAMPS, 1961. These five young people were the junior champions at Woodstock Lanes in 1961. From left to right are John Mower, Ross VanWagenen, Potch Harder, Gary Port, and J. Chalmers. (Courtesy John Mower.)

93

THE ICE BARN ON LASHER LANE. Bob Barclay and a helper work to clear land in front of the chestnut ice barn. Clarkson Reynolds sold ice locally, and he and his family lived on Lasher Lane. (Courtesy Bruce Reynolds.)

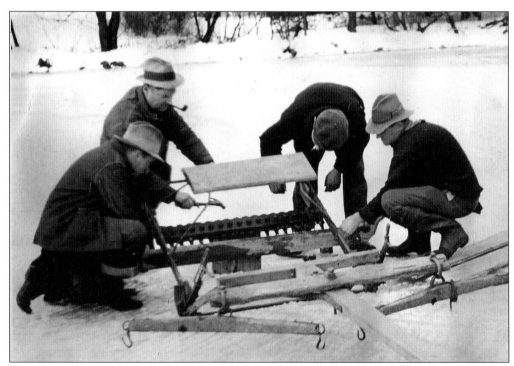

WORKING ON THE ICE, 1936. Preparing to harvest ice from the pond off Lasher Road are, from left to right, Butch Yeager, Victor Rey, Dave Mazetti, and Clarkson Reynolds. (Courtesy Bruce Reynolds.)

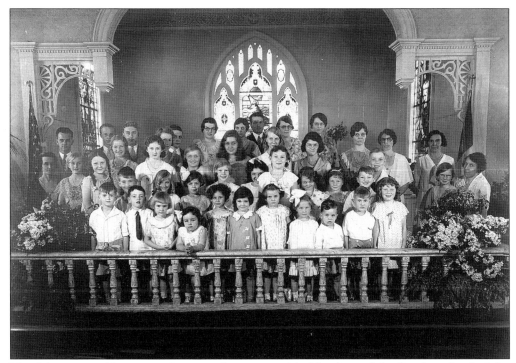

THE METHODIST EPISCOPAL SUNDAY SCHOOL, 1932. Members of the Sunday school of the Woodstock Methodist Episcopal Church are, from left to right, as follows: (front row) Victor Lapo, Bob Smith, Ginnie Hastie, Jean Shultis, Judy Cohen, unidentifed, Doris Lapo, two unidentified children, Ronald Mower, and unidentified; (middle row) Rye Elwyn, unidentifed, Barbara Herrick, Bob Hastie, unidentifed, Ruth Shultis, Louise Shultis, unidentifed, Janet Cochran, two unidentified children, Jean Lasher, two unidentified children, and Elizabeth Clough; (back row) ? Elwyn, Dick Short, Hugh Elwyn, two unidentified children, Helen Short, two unidentified children, Gertrude Snyder, ? Peckham, Gertrude Reynolds, Ken Reynolds, and Myra Cochran. (Courtesy Harley Avery.)

THE WOODSTOCK MOTEL. Joe and Nora Holdridge opened the Woodstock Motel in 1954. It was located on the corner of Orchard Lane and Route 212. (Author's collection.)

THE ELWYN HOUSE, ON TINKER STREET. Larry Elwyn (right) pauses on the sidewalk in front of the house built *c*. 1810 as a hotel by his grandparents John Elwyn and Maria Bonesteel Elwyn. (Courtesy Harley Avery.)

THREE SISTERS. Laura Bess (left), Melissa (center), and Margaret Elwyn—daughters of Larry Elwyn and Mahala Shultis—pose for the photographer *c*. 1900 in their yard on Tinker Street. Their nephew Deanie Elwyn followed in the footsteps of great-grandfather John Elwyn and his son Alexander Elwyn and became a restaurateur and Woodstock businessman. (Courtesy Jon D. Elwyn.)

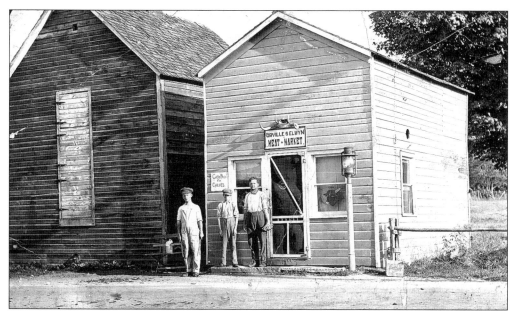

ORVILLE ELWYN'S MEAT MARKET. This small building was the meat market run by Orville Elwyn (left). It stood on the north side of Tinker street, near the Elwyn Hotel. The sign on the building says, "Cash paid for calves," and there is a calf head mounted in the right-hand window. (Courtesy Harry Park.)

SLEDDING ON TINKER STREET. Two members of the Elwyn family prepare to go sleigh riding on the big sledding hill across from the Johnson farm. The building in the background still stands on Tinker Street. Behind it looms snow-covered Overlook Mountain. (Courtesy Jon D. Elwyn.)

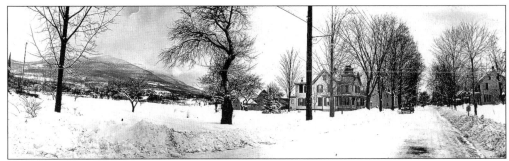

TINKER STREET. This winter view of Tinker Street was taken looking eastward. The Lasher Funeral Home is on the left, and the Lasher apple orchards (far left corner) stretch all the way back to the area now known as Orchard Lane. (Courtesy Ken Peterson.)

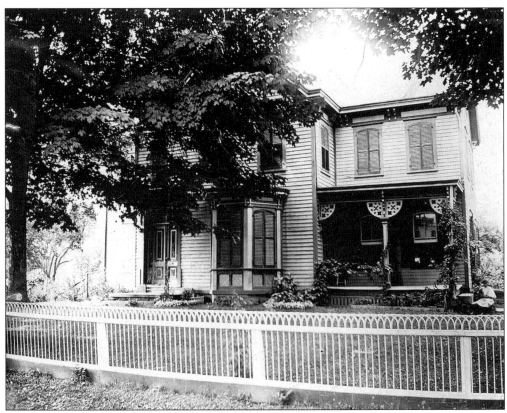

THE LASHER FUNERAL HOME. This building dates from *c.* 1880. It is pictured before the porch was added. The white fence provided a border for the property. An exact replica of the house, built by another Lasher, stands on the north side of Route 212 across from the entrance to Chestnut Hill Road. (Courtesy Ken Peterson.)

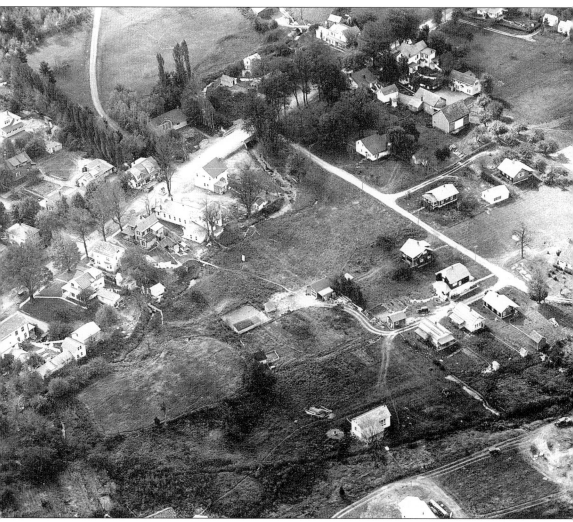

THE INTERSECTION OF TINKER STREET AND LIBRARY LANE. This early aerial photograph was taken *c.* 1935. The wooden town hall and the two-story wooden building are visible just east of the bridge. The Woodstock Library is the first building on the left on Library Lane. (Courtesy Ken Peterson.)

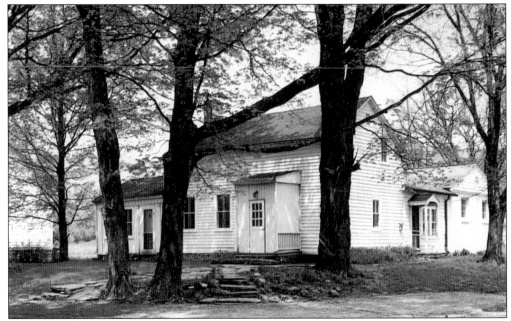

THE WOODSTOCK LIBRARY. The library is located in the former home and office of Dr. Larry Gilbert Hall, who died in 1836. Victor Lasher purchased the house from Hall's widow, Catherine Longyear Hall, in 1885. The Woodstock Club's library, formerly housed in a barn owned by George Neher, moved into its new home in the late winter of 1927. Over the years, the building has been expanded to meet the community's needs. (Author's collection.)

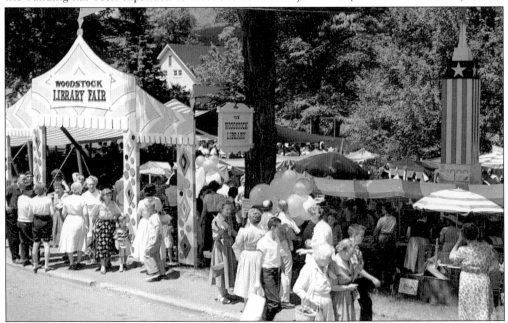

THE LIBRARY FAIR. The library began its country fair tradition in 1931. In later years, the annual fair was held on the third Thursday in July. No admission was charged. Each year, thousands of people descended on Woodstock to search for clothing bargains and to spend some time socializing with friends and neighbors. (Author's collection.)

CROSSING THE BRIDGE BY LIBRARY LANE. Until the 1950s, the building on the left just east of the bridge was a small store with apartments. The wooden town hall is just behind it. (Author's collection.)

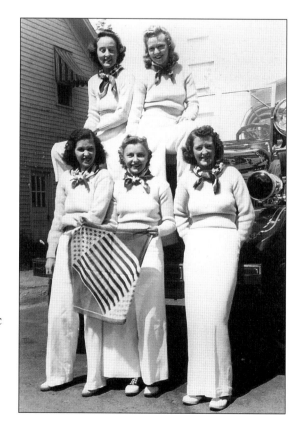

HEADING FOR A FIRE COMPANY PICNIC IN PHOENICIA. Off to a fire company picnic in Phoenicia c. 1939 are, from left to right, the following: (standing) Flo Davis, Alma Stoutenberg, and Dot Bell; (seated) Marion Bell and Winnie Davis. (Author's collection.)

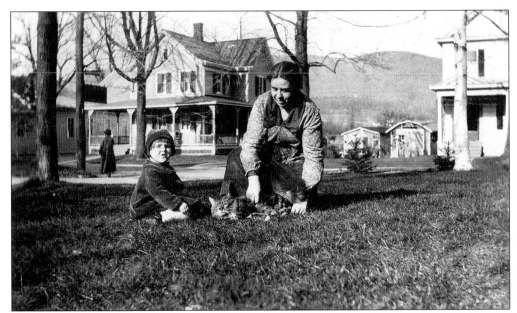

PLAYING WITH THE KITTY. Members of the George Neher family play with the cat on the front lawn of their house, located on the corner of Neher and Tinker Streets. At one time, the Woodstock Town Court was located in the house shown in the left background. Through the open lot, Mead's Mountain is visible. (Courtesy the Marie Raymond collection, Historical Society of Woodstock.)

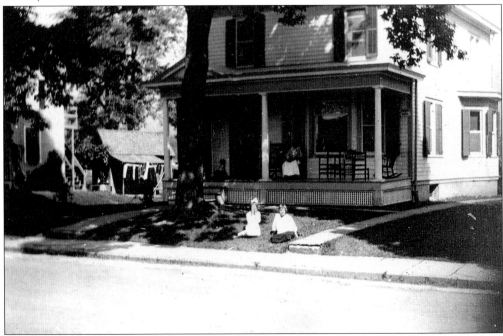

ALONG TINKER STREET. This building is just east of the George Reynolds house. The majority of buildings on this tree-lined main street of Woodstock were family homes with porches, yards, walkways, flower boxes, and gardens in the back. (Courtesy the Marie Raymond collection, Historical Society of Woodstock.)

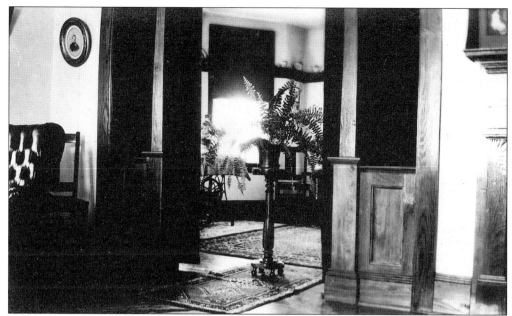

ORNATE WOODWORK, INSIDE THE NEHER HOUSE. The Neher family first appeared in Woodstock as part of the small community of Montoma. Pictured is some of the ornate woodwork inside the George Neher house. During the 1930s and 1940s, George and Clark Neher were very involved in the construction and real estate trade in Woodstock. (Courtesy the Marie Raymond collection, Historical Society of Woodstock.)

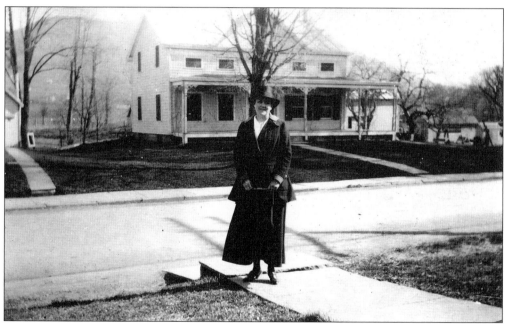

COLONIAL-STYLE HOUSE, TINKER STREET. Built in 1807, this house has a wide sitting porch, a long front lawn, fields behind the house, and Overlook Mountain beyond. The woman across the street from the house is unidentified. (Courtesy the Marie Raymond collection, Historical Society of Woodstock.)

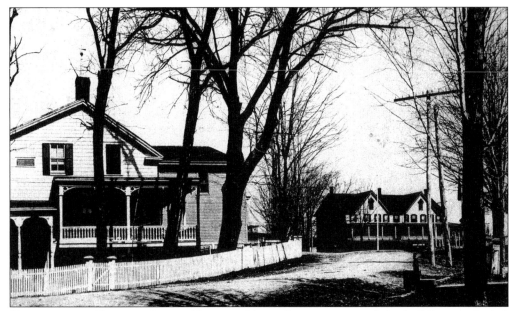

CROSSING THE TANNERY BROOK BRIDGE. Abram Rose once owned the building on the left just east of the Tannery Brook Bridge. Rose's general store is visible just behind it. (Courtesy Harry Park.)

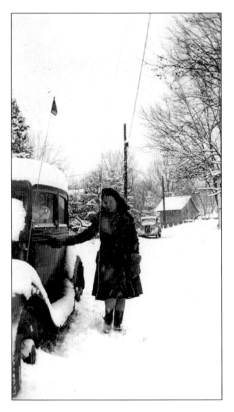

THE HERRICK HOUSE. On a wintry day, Hope Herrick stands in front of the Bruce Herrick house on Tannery Brook Road. With only a small amount of traffic in Woodstock in the early 1940s, parking was allowed on Tannery Brook Road. There was also a sidewalk along the east side of the roadway. (Courtesy Sharon Rushkoski.)

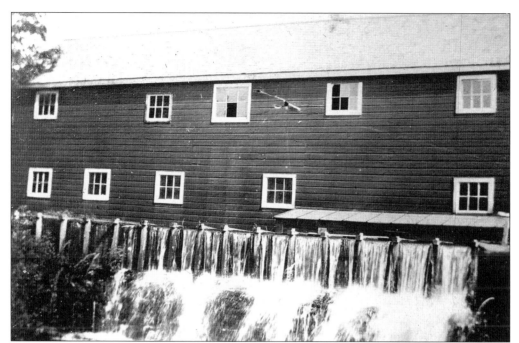

SULLY'S WATER-POWERED MILL. Irish entertainer Dan Sully married Louise Dulaney, a niece of the Wilber brothers of Mink Hollow. The couple joined some New York theater people in starting a theater colony in the Hollow. Eventually, the Sullys moved into the center of town and established this mill on the Sawkill. (Courtesy the Ada Wilber Herrick collection, Historical Society of Woodstock.)

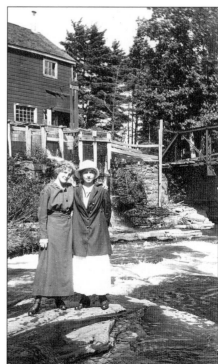

COOLING OFF AT SULLY'S MILLSTREAM. Members of the Vera Shultis family pose in front of Sully's Mill in August 1915. (Courtesy Roger Shultis.)

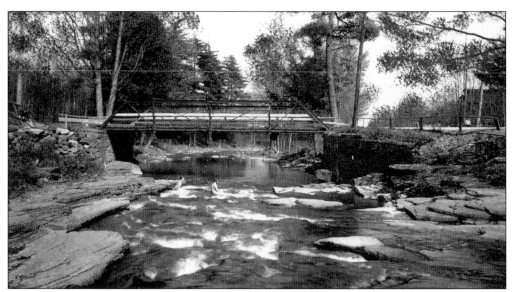

THE SWIMMING HOLE AT SULLY'S BRIDGE. This view, looking east, shows the swimming hole at Sully's Bridge, a popular cooling-off spot near the center of Woodstock. (Author's collection.)

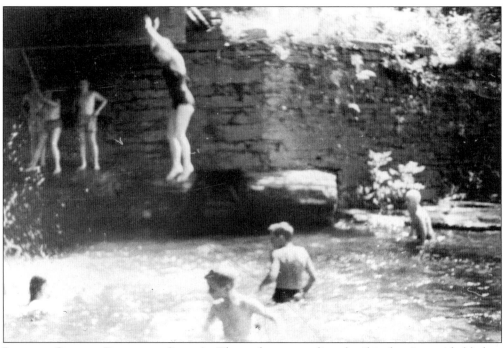

JUMPING OFF THE BRIDGE AT SULLY'S. The rocks surrounding the "big deep" provided ledges on which to picnic. The water was deep enough to allow those brave enough to drop from the bridge into the cool water. For safety reasons, this sport and many other memorable old traditions are no longer allowed in Woodstock. (Author's collection.)

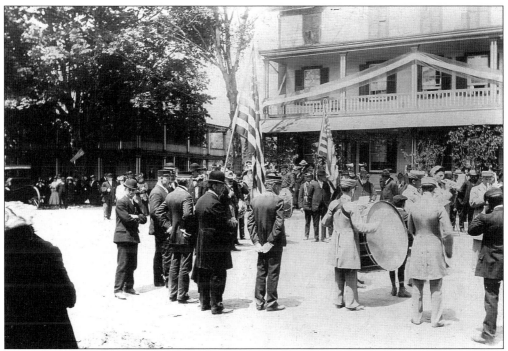

DECORATION DAY CEREMONIES. Civil War veterans, perhaps joined by members of the Lake Hill band, gather in front of the Woodstock Inn for Decoration Day ceremonies *c.* 1905. The special day was instituted in May 1868 to encourage the decoration of Civil War veterans' graves. It later became what it is today, Memorial Day. (Courtesy Denise Clark.)

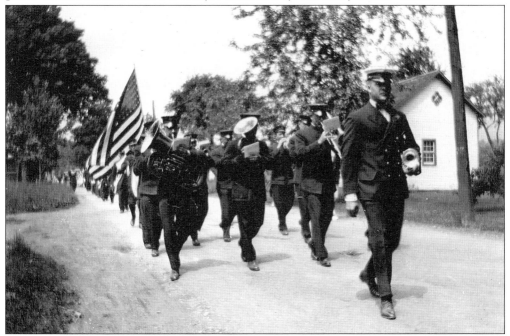

PARADING TO THE CEMETERY. John D. Mower leads the band up Rock City Road for the Decoration Day services *c.* 1925. (Author's collection.)

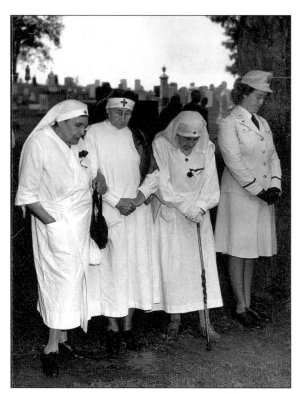

MEMORIAL DAY SERVICES, MAY 30, 1945. Reflecting on their memories of the two world wars are, from left to right, Lillian Downer, Della Riseley, Dr. ? Arnold, and Doris Dock. These services were held on Memorial Day of 1945. (Courtesy Velma Grazier.)

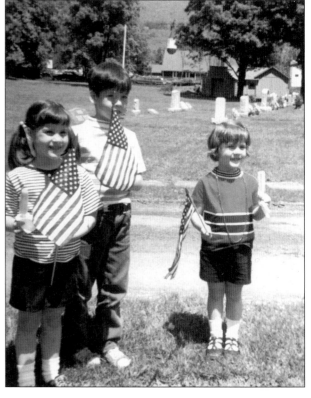

MEMORIAL DAY, 1971. Each year, Woodstockers gather to honor all who died in the service of their country. In the Woodstock Cemetery after the parade, three of them strike a patriotic pose. They are, from left to right, Andrea Reynolds, Jimmy Reynolds, and Leighann Reynolds. (Courtesy Bruce Reynolds.)

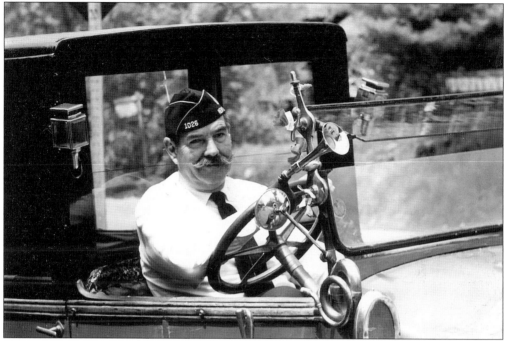

THE RENAULT LANDAULET. Louis Lewis frequently used his red Renault Landaulet to transport local dignitaries in the Memorial Day parade. (Courtesy Alice Lewis.)

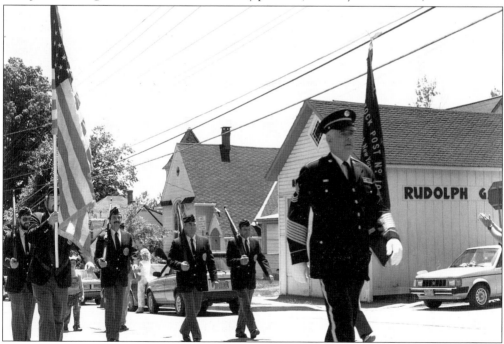

LEADING THE PARADE. Members of American Legion Post 1026 organize Woodstock's Memorial Day parade each year. Shown is Lud Baumgarten—veteran of China, Burma, and India—leading the parade up Mill Hill Road. Baumgarten served on the Woodstock police force. His nickname was the Red Baron. (Author's collection.)

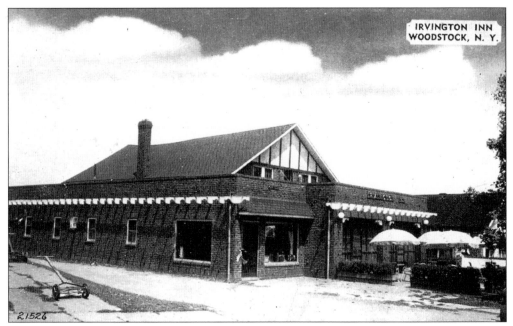

The Irvington Inn, Mill Hill Road. The Irvington Inn, a red brick structure that incorporates the Stanley Brinkerhoff Longyear carriage sheds, stands on Mill Hill Road. Members of the Longyear-Wilson family operated the inn until the late 1950s. (Author's collection.)

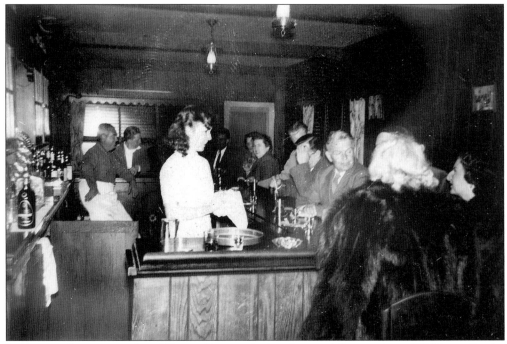

Inside the Irvington Inn. Winnie Davis is drying glasses while proprietor Bill Dixon (in the apron) sits and converses with Stubby Wolven. For dancing and socializing, the Irvington was the place to be on Saturday nights during the 1950s. (Author's collection.)

Six

MILL HILL
TO ZENA

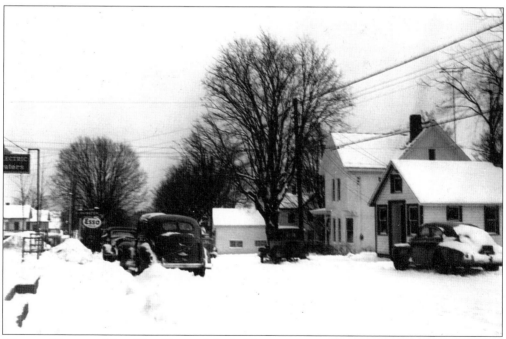

WINTER TRAFFIC, MILL HILL ROAD. It looks like one-way traffic down the hill. The old saying goes, "After Labor Day you could roll up the sidewalks and roll a bowling ball down the center of town and never hit anyone." The Esso sign on the left is in front of Peper's garage. The little building in the right foreground has been replaced by a concrete structure. The next building is a candle store today. Off in the distance can be seen Mrs. Rudolf's Gallery, which is now Bread Alone. (Courtesy Shelli Ahlheim Mellert.)

ALL BUNDLED UP. Allan Mower stands all bundled up in front of his family home on Maple Lane. In the background are the Stanley Brinkerhoff Longyear carriage sheds, later converted into the Irvington Inn. (Author's collection.)

IN THE BACKYARD, MAPLE LANE. The Mowers had a large garden on their property in the center of town. They sold the excess produce from that garden to the F.B. Happy-Mower Market, on Tinker Street. In the backyard is John D. Mower, with a four-point whitetail deer. (Author's collection.)

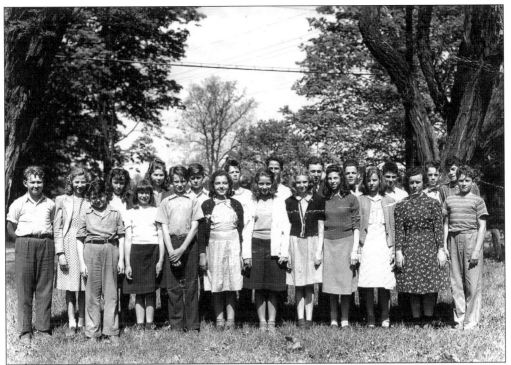

UPPER-GRADE STUDENTS, WOODSTOCK SCHOOL, MILL HILL ROAD. Although many of the faces are familiar, the names tend to fade away with time. The upper-grade students attended the white wooden schoolhouse that still stands behind the old Grand Union building. The lower-grade students attended the red barnlike building a short walk up Mill Hill, across from the Mobile station. (Courtesy Lorraine Elliott.)

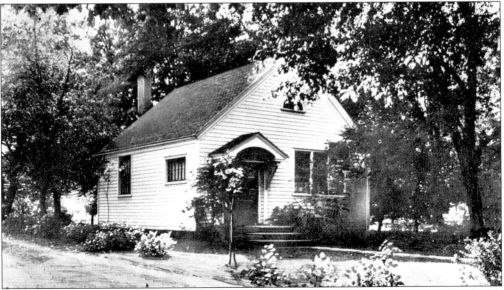

THE FIRST CHURCH OF CHRIST, SCIENTIST. This building once stood next to the Woodstock School on Mill Hill Road. Both the church and the school were moved to accommodate the new Grand Union supermarket. (Courtesy Andre Neher.)

THE NEW A & P. Times were changing and Woodstock was growing. Soon, the town had two full-service supermarkets. The A & P was in the Bradley Meadow's Shopping Plaza. Although it took about 15 years, eventually the small mom-and-pop grocery stores and meat markets succumbed to the competition. (Courtesy Denise Clark.)

HURRICANE DONNA MEETING THE ROUTE 375 BRIDGE, 1960. The bridge is nearly covered by the floodwaters from Hurricane Donna, pounding down the Sawkill Creek near the Woodstock Country Club. (Courtesy Denise Clark.)

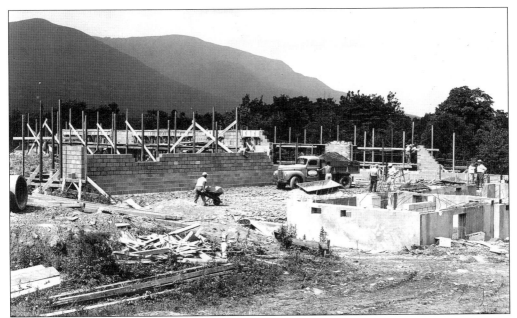

BUILDING THE WOODSTOCK SCHOOL. In the early 1950s, Woodstockers decided there was a need for a larger school building. At first, the design was to be kept in line with a small Colonial-style building. The end result was a functional brick-and-mortar building on land that was once part of the Aaron Riseley farm. Shown are workmen building the school. (Courtesy the Harry Siemsen collection, Historical Society of Woodstock.)

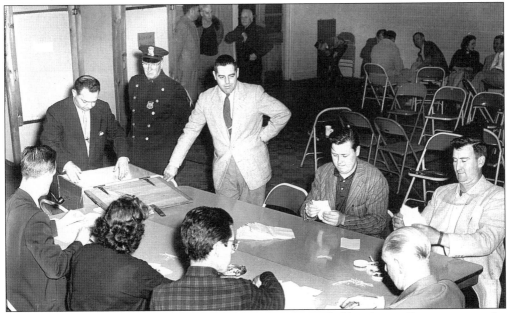

COUNTING THE PAPER BALLOTS. This intensely debated vote, held in the small gymnasium at the front of the new school, decided the fate the Woodstock school districts. The outcome of the vote created the Onteora Central School District. Counting the paper ballots are, from left to right, Al Moskowitz (standing), Clancy Snyder (the officer), unidentified, Ted Gertsema, Bob Hastie, and others. (Courtesy the Kiki Randolph collection, Historical Society of Woodstock.)

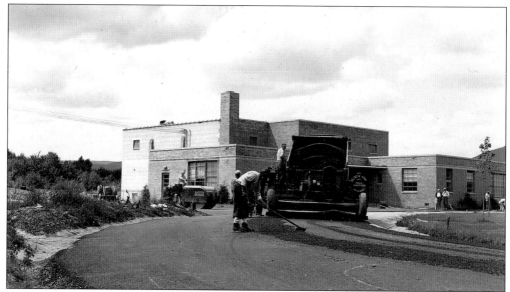

THE NEW WOODSTOCK SCHOOL. This school was built in response to an increase in enrollment in the Woodstock area schools. Workmen put down blacktop in preparation for opening day. (Courtesy the Harry Seimsen collection, Historical Society of Woodstock.)

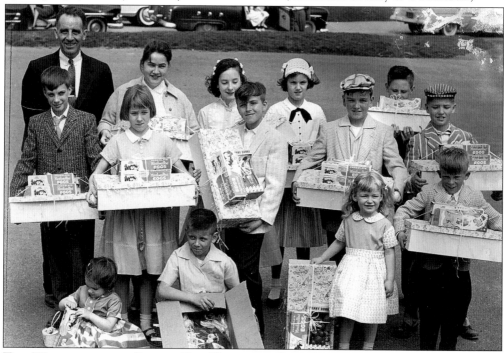

THE WINNERS OF THE EASTER EGG HUNT. Much to the delight of Woodstock children, Forno's Pharmacy sponsored an Easter egg hunt at the Woodstock Elementary School each spring. From left to right are the following: (front row) Sally Kinns, John Mower, Linda Cousins, and Craig Hubble; (middle row) Jim Kinns, unidentified, George Kipple, Jay Van Wagenen, and Ralph Wickman; (third row) Joe Forno, unidentified, unidentified, Elaine Cousins, and Bob Gordon. (Courtesy John Mower.)

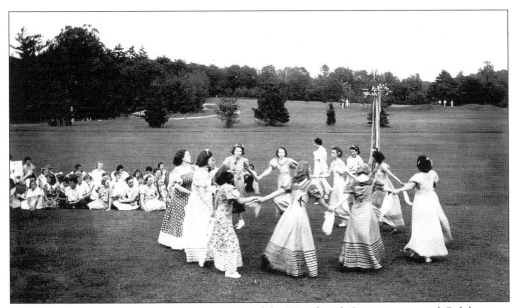

DRESSED FOR THE MAYPOLE DANCE. As part of the Woodstock Sesquicentennial Celebration, these women in Woodstock dresses dance at the Woodstock Country Club, between the first and second tee. (Author's collection.)

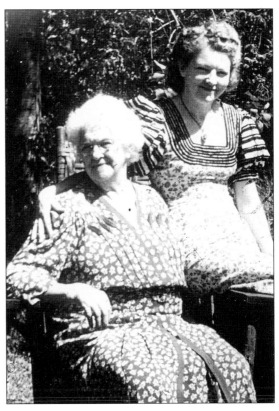

THE WOODSTOCK DRESS DESIGNER. Augusta Louise Allen, an accomplished seamstress, designed the popular Woodstock dress in early 1917. She is pictured with her daughter Ruth Allen Brown. She made the cotton, velvet, or taffeta dresses at her kitchen table, often working at the sewing machine all night. The women who danced with the group Cheats and Swings in the 1930s and 1940s were the envy of all, wearing their Augusta Louise Allen dresses. (Courtesy Victor Allen.)

THE COUNTRY CLUB SWIMMING POOL. The club was formed in the late 1920s at the site of an old gristmill dating back to the 1840s. The millwheel is still visible under the porch. The pool, created by a dam, provided the members and their families with a cooling-off spot on warm summer days. (Author's collection.)

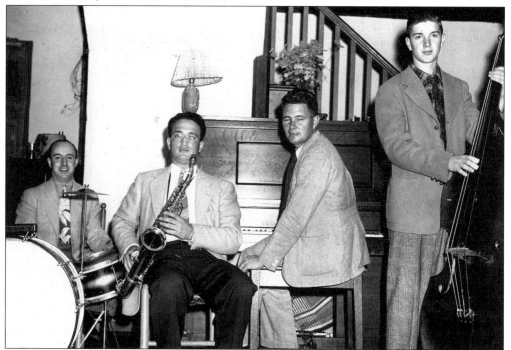

THE FRED ALLEN BAND. The Fred Allen band entertains on a Saturday night at the Woodstock Country Club. From left to right are Palmer Carnwright on drum, Jay Molyneaux on saxophone, Fred Allen on piano, and Victor Allen on bass. (Courtesy Victor Allen.)

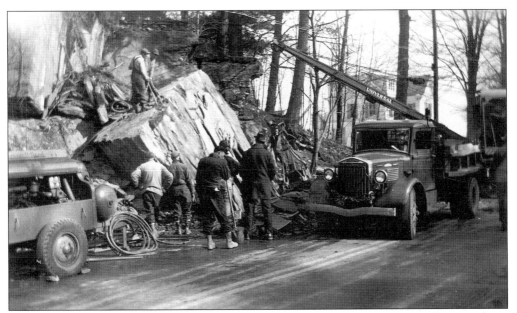

THE ROCK SLIDE ON ROUTE 212. Just past the country club along Route 212, there is a large outcropping of rock. The spring thaw caused part of the rock to let loose and slide into the road. (Courtesy Doris DeWitt.)

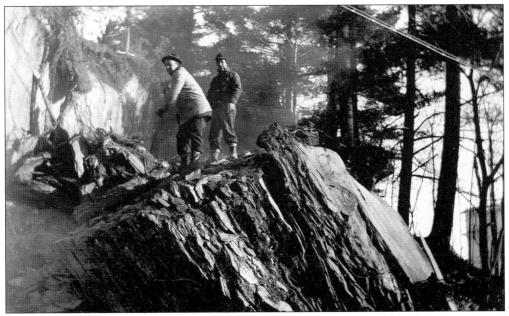

BREAKING UP THE ROCK SLIDE. Johnny Holumzer and others work to demolish the rock and cart it away from Route 212. Artist Carl Eric Linden lived in the Tudor-style home atop the ledge. This is the site where the Lutheran congregation first built a church in 1806. (Courtesy Stewart DeWitt.)

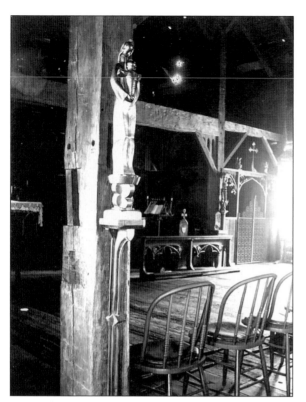

ST. DUNSTAN'S CHAPEL. Once located on Route 212 just past Chestnut Hill Road, this chapel served many of the artists now living in the Woodstock area. The building was destroyed by fire in 1945. (Author's collection.)

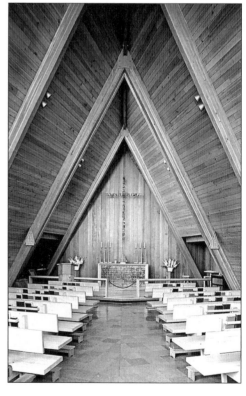

ST. GREGORY'S EPISCOPAL CHURCH. Members of the Episcopal congregation first held services in a corncrib located across Route 212 from the present site of St. Gregory's Church. The A-frame building, with stained-glass windows, was erected c. the late 1950s. (Author's collection.)

LAZY SUMMER DAYS. Swimming at Little Deep just off Zena Road near the Downer cornfields are, from left to right, Nancy Kline, Kathy Lubart, and Marianne Downer. Stream access was allowed all along the Sawkill until the mid-1970s. Along with swimming, summer activities included skimming rocks, chasing minnows, catching frogs, watching the trout swim in the deep pools, and listening to water babble over the rock. (Courtesy Marianne Sjursen.)

THE OLD ZENA MILL. Zena is referred to on old maps by its Indian name *Waghkonk*. The gristmill is on land that was once part of the Hardenberg Patent and dates back to the 1700s. (Courtesy the Harry Seimsen collection, Historical Society of Woodstock.)

THE SAGENDORF-HEERMAN HOUSE. This is one of a handful of stone houses in Woodstock. Located on the west side of Zena Road, it is built in the Dutch colonial style and is believed to predate the American Revolution. (Courtesy Town of Woodstock Historic Structure Photograph Collection.)

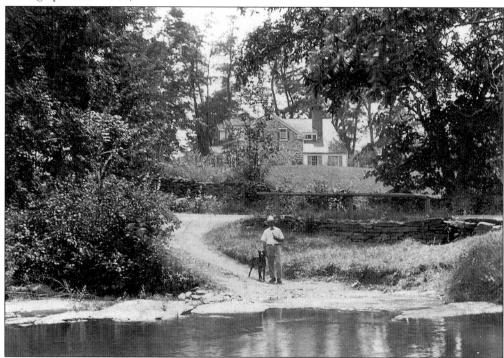

THE FORDING PLACE. The well-worn path from Zena Road across the Sawkill Creek to the Kidd-Mellert farm provided a shortcut during times of low water. The 18th-century stone house sits on the ridge in the background. (Courtesy Dave Mellert.)

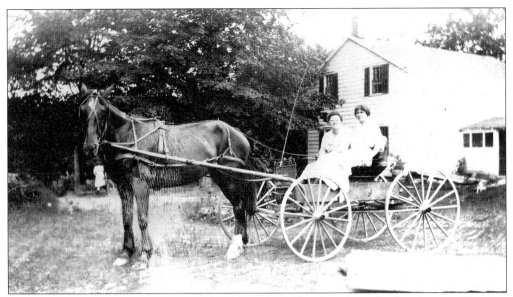

LEAVING THE FARMHOUSE. Olga Lynch and her friend head out from the farmhouse at Danolga Acres, located on the west side of Zena Road. The house, which dates back to 1790, had a blacksmith shop located near the barn. (Courtesy Doris DeWitt.)

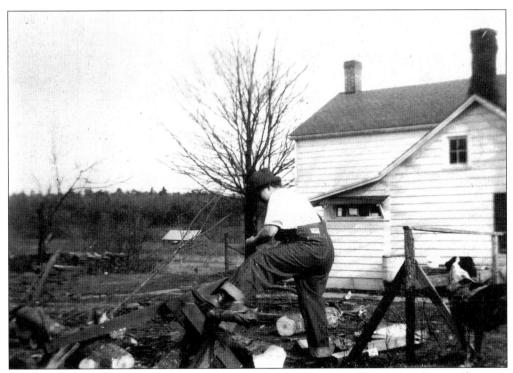

SAWING WOOD. This woodshed was located in back of the Dan Lynch farmhouse. Shown is one person using a two-person saw. Judging by the size of the logs, the person whose foot was doing the steadying has his work cut out for him. (Courtesy Stewart DeWitt.)

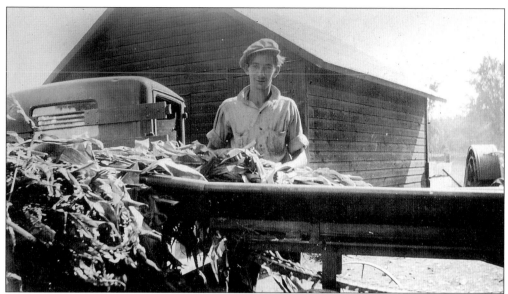

UNLOADING CORN IN ZENA. When Woodstockers think of Zena, they think of the Zena cornfield. Monty DeWitt moves a load of corn from his truck to a conveyor belt. (Courtesy Stewart DeWitt.)

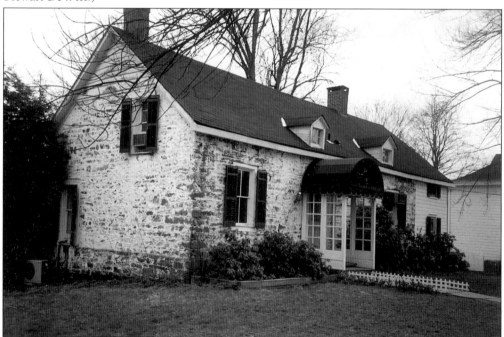

THE ROWE-CARNRIGHT HOUSE, ZENA FOUR CORNERS. The Rowe-Carnright house, at the Four Corners in Zena dates back to before 1750, according to the Junior League Woodstock House Survey of 1966. One of its owners, Wilhelmus Rowe, is recorded to have owned a negro slave named Pompey, a wench named Elizabeth, 50 head of sheep, 7 milch cows, fine old furniture, a complete weaving outfit, looms, and quills recorded in his will of 1803. The Carnright family worked this farm well into the 1950s. (Courtesy Town of Woodstock Historic Structure Photograph Collection.)

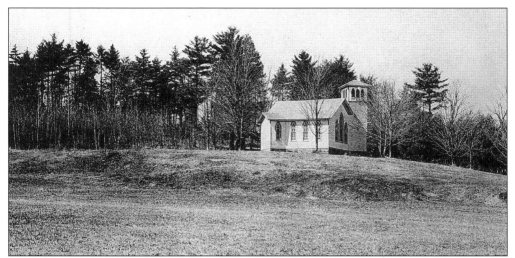

THE ZENA DUTCH REFORMED CHURCH. The Christian Endeavor Society held successful fairs and suppers in the late 1920s and early 1930s. At times, they would serve delicious chicken dinners to as many as 300 people in the Zena Dutch Reformed Church hall. The deed for the small, private burying ground south of the church behind the Long Homestead was recorded in 1868. Zena Four Corners also had a little general store that was run by the Hibyan family. (Author's collection.)

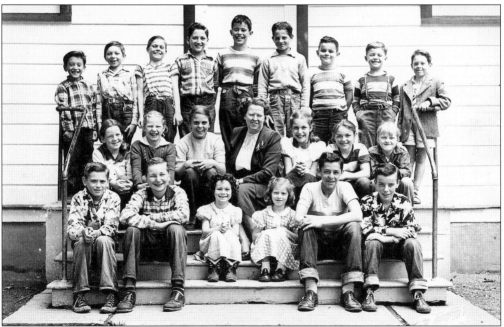

THE CLASS OF 1952, ZENA SCHOOL. Members of the Class of 1952 at the Zena School are, from left to right, as follows: (front row) Gary Kaiser, Stewart DeWitt, ? Ladin, John Hung, Bill Baldinger, and Herbert Vogel; (middle row) unidentified, Patty Klementis, Phyllis Beers, teacher M. Mallow, Carol DeWitt, Bonnie Kaiser, and Sandy Klementis; (back row) Richard Mellert, Albert Holumzer, Charlie Beers, John Mellert, Mike Ledegar, Jimmy Klementis, Ricky Ledegar, Jon Joy, and unidentified. The school had a band, and its members wore special blue-and-gold uniforms when they performed. (Courtesy Stewart DeWitt.)

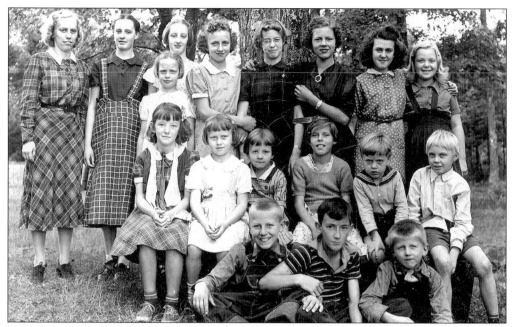

THE LITTLE SCHOOL AT DAISY. John Joy Road heads east and intersects with Glasco Turnpike. Zena children who lived at this end of the road attended school in Daisy, on the Glasco Turnpike near Shultis Corners. From left to right are the following: (front row) Hyland Winne, Tom Hyatt, and H. Winne; (middle row) Mary Hyatt, Hope Heinlein, unidentified, ? Winne, Ernie Koehn, and Pete Koehn; (back row) teacher ? Robinson, Mildred Reynolds, Alice Reynolds, Lena Reynolds, M. Winne, unidentified, Beatrice Winne, unidentified, and Juanita Ferbach. (Courtesy Lena Woodard.)

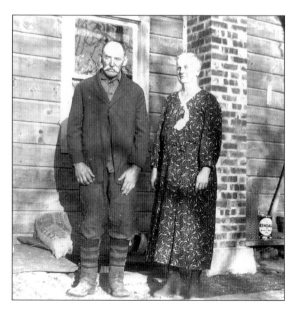

THE JOHN JOY FARM. John and Maggie Joy ran the John Joy farm, established *c.* 1880, half a mile from the Glasco Turnpike and John Joy Road intersection. They kept pigs, cows, and chickens, and they raised buckwheat, which they sold to a mill in Quarryville. They had a garden and made their own butter and fresh cream. Their son Charlie Joy did the stone work on the town's war memorial. (Courtesy Lena Woodard.)

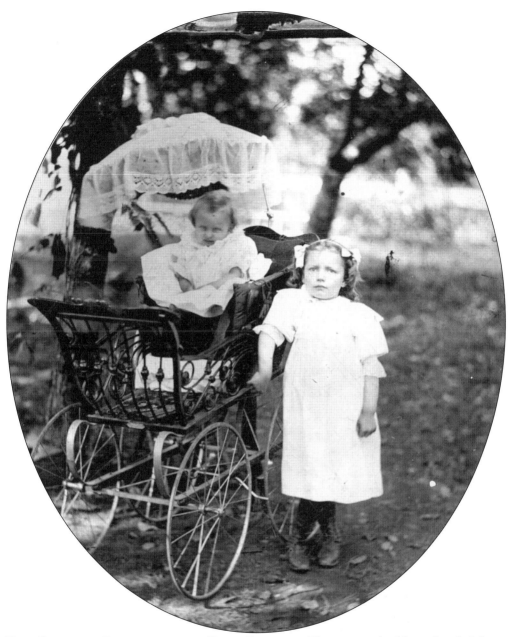

Two Reynolds Children with a Baby Carriage. This tintype had been handed down through the Myron Reynolds family. Over the past 150 years, members of the Reynolds family have intermarried with the Short, Elwyn, Joy, and Shultis families, to name just a few. (Courtesy Lena Woodard.)

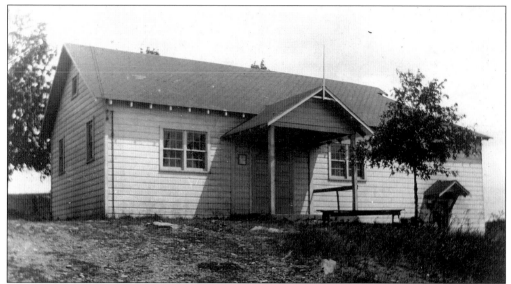

THE ZENA COUNTRY CLUB, JOHN JOY ROAD. The clubhouse was built with volunteer labor and was opened in 1925. It had a kitchen, a stage, and plenty of room to socialize and entertain. Its purpose was to establish a community center in the town of Woodstock. (Courtesy Doris DeWitt.)

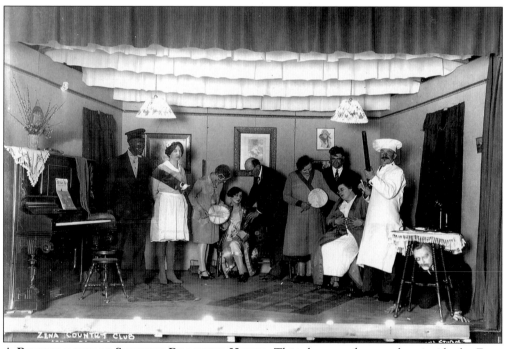

A PERFORMANCE OF *SNICKERS BOARDING HOUSE*. This photograph was taken inside the Zena Country Club. The actors and actresses were all friends and neighbors. Dan Lynch (third from the right) wrote many of the plays for the group. Pictured with Lynch, from left to right, are Ernest Baldinger, May Hung, Olga Lynch, Julia Klementis, Howard Harcourst, Mrs. Fred Thaisz, Lela Harcourt, A. Holumzer, and William Klementis (under the table). (Courtesy the Ruth Holumzer collection, Historical Society of Woodstock.)